DISLOCATIONS

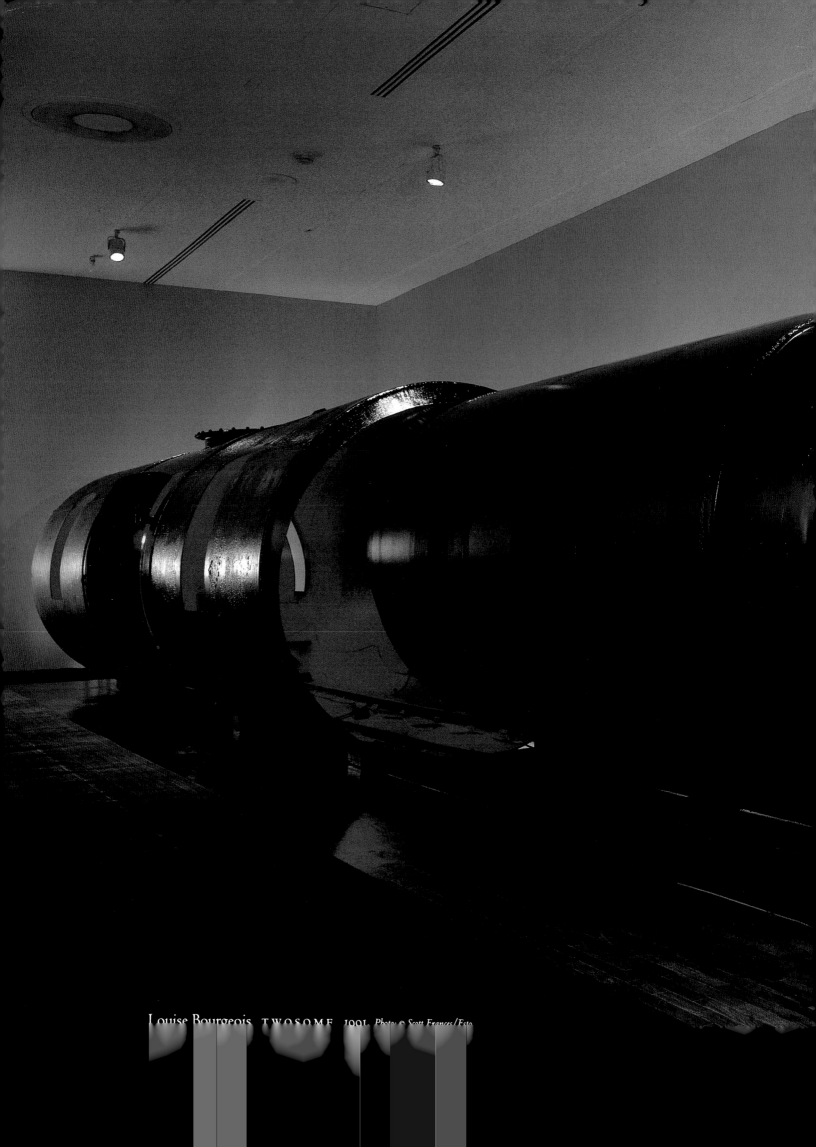

Louise Bourgeois TWOSOME 1991 Photo: © Scott Frances/Esto

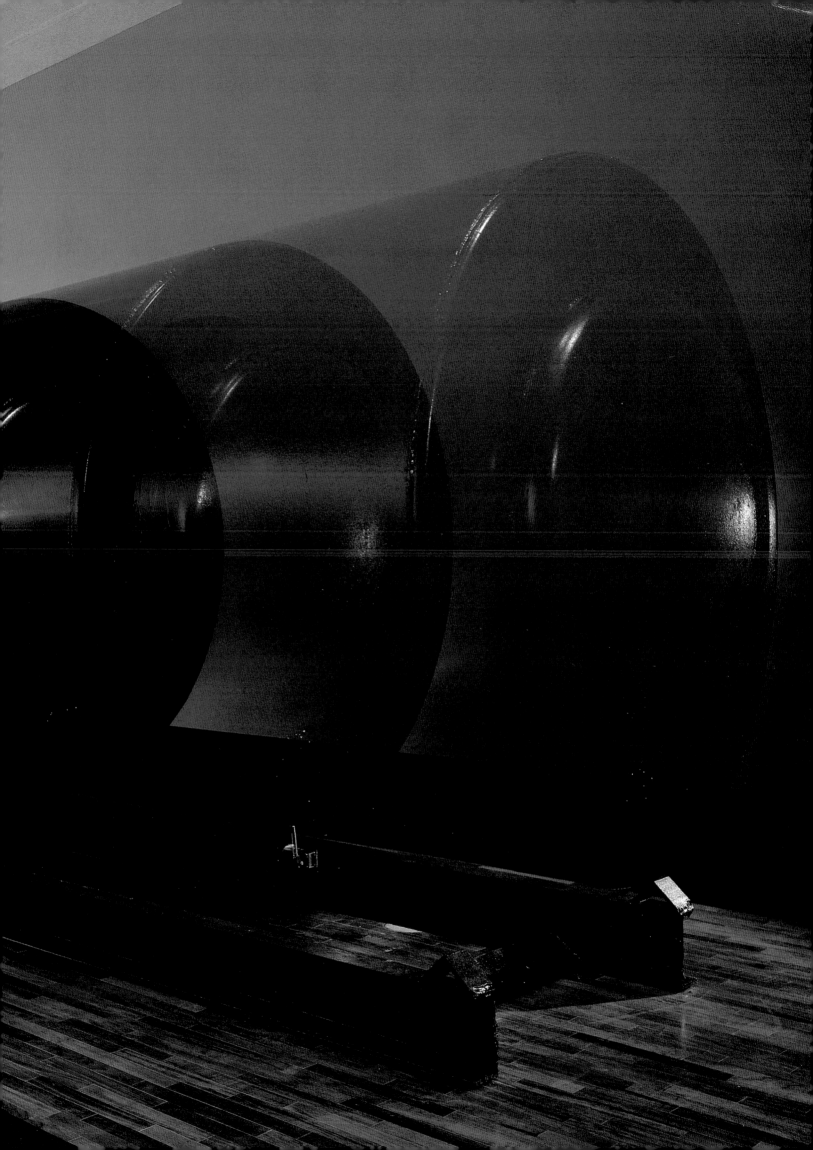

CHRIS BURDEN

The Other Vietnam Memorial

This is a memorial to the approximately three million North and South Vietnamese, military and civilian, who lost their lives during the United States of America's involvement in the war in Vietnam from 1963 to 1974. Very few records were kept, a great many bodies were buried in mass graves, the headstones that do not bear the names simply read SU "HERO". The completed list of three million Vietnamese names on these pages below will represent the three million Vietnamese dead.

CHRIS BURDEN

Chris Burden. THE OTHER VIETNAM MEMORIAL. 1991. *Photo: © Scott Frances/Esto*

This one is easy to remember. It looks like a hotel room. In the middle ground there is a slender bed where a woman lies naked, she's bleeding from the mouth, and has a towel over her neck. In the window behind her we see the faces of three men that look very much alike, the way typical handsome 1920s fellows would look, dummylike in their simplicity. In the distance there is a landscape of mountains with snow. Now let's go back to the woman who is in the middle and then two steps forward to the right, there is a man with his right hand in his pocket and his left hand on a table where a phonograph sits. All right, a few steps forward and we have the entrance. Hidden behind walls are two men. One on the left, holding a club, and one on the right with a net. They're both wearing formal attire and bowler hats, and they look like they could be policemen hiding from the perpetrator. The first thing that strikes you is the gruesome image of an act of violence, blatantly simple and crude. It reminds me of that detached irony of Hitchcock. It's like a whodunit, you cannot tell what's going on. There's this incredible objectivity, all the possibilities are there for you, but you don't know the syntax. I remember clothed men standing around a woman who is not only nude but dead, as if she was a sacrifice in the middle of the room. Your eyes go immediately to her. What I remember most is the blood coming out of her mouth and the face of the assassin. He just looks evil. The action takes place in a room. The victim is female. She looks like someone who's been dead for a while. The other characters are male in gentlemen's long coats and hats. There are no expressions on their faces. It looks sort of contrived, like a bad melodrama, like a "B" movie. The blood is red, the skin is pink, the sky is blue. There's a lot of pink flesh, red blood, guys in black. The background is blue with French ironwork on the balcony, the bedroom is beige, but the only striking color is that blood painted red that looks like ketchup. Large, awful. There's a pink boa around the neck of a naked woman lying on a table like a piece of lamb. That's all I remember. I think it is a dim piece of art. There's nothing visceral or juicy about the way it is painted. It's just dull and dry. No meat. It's a painting with a smooth surface. an easy one to spot check. It is approximately five feet high and seven feet long. It is framed in a plain, dark, walnut-stained molding, something austere. I never liked it. I don't like stories in painting. I don't like trying to figure them out. That's why I never gave it any time. I guess it's the nightmare of a woman who's been beaten up, laying on a red sofa, with a trickle of blood coming out of her mouth. There is a man talking or listening to one of those old Victrolas, and a window with three men looking in. You wonder how come she isn't dressed when all the men are. It's a painting that I try to avoid as much as possible. It causes me repulsion. There was a crime committed and yet it's like nothing has happened. You sense the indifference of people just standing by a dead corpse. You can draw strange conclusions from looking at it, all the way from feminism to something else. It's just one more picture where the woman is naked and the men are clothed. There's a body. I believe it's male. It's just flat. I don't think there is any woman in the painting, although there is some strange feeling of rape. What disturbs me is that the body was tied up, with a gag over her mouth, naked and stabbed. It has a film noir sort of feel, a mystery novel look to it. The puzzle is there. You have all those little clues that will probably lead you nowhere; there are men dressed in dark coats and black bowler hats, the way Albert Finney was dressed in *Murder on the Orient Express*, placed in a room with a dead body. In the center, the one who seems to be the perpetrator is lifting the needle of a phonograph. Two weird-looking individuals are hiding to the side. There is a face looking from the balcony, almost like a sun on the horizon. And, when you look at her carefully, you realize that the towel probably conceals a decapitated head. Okay, there's a man with a suitcase, and there's a woman on a bed with a slashed throat and blood dripping from the side of her mouth. It's a good painting. A lot of people talk about it. They wonder why she's been murdered, but, honestly, I don't know why he slashed her throat. It could have been her fault, too, you just don't know about these things. I think it's just a murder scene. Men in dark suits, a pale woman and dashes of red blood. That's all I remember.

GRAMOPHONE

Blood out of mouth

Sophie Calle. GHOSTS. 1991. *Photo: © Scott Frances/Esto*

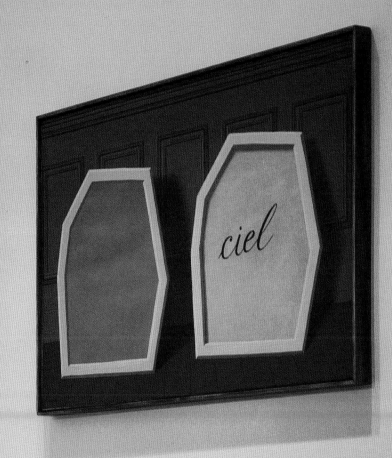

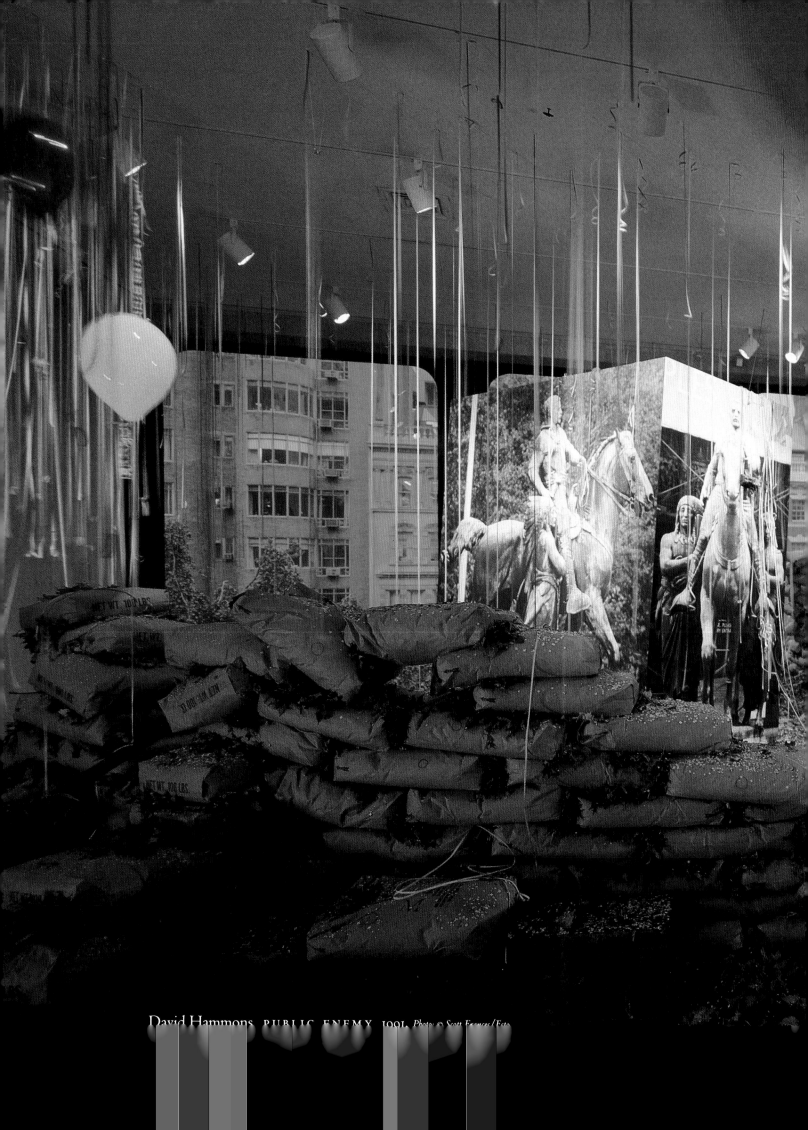

David Hammons PUBLIC ENEMY 1991. Photo: © Scott Frances/Esto

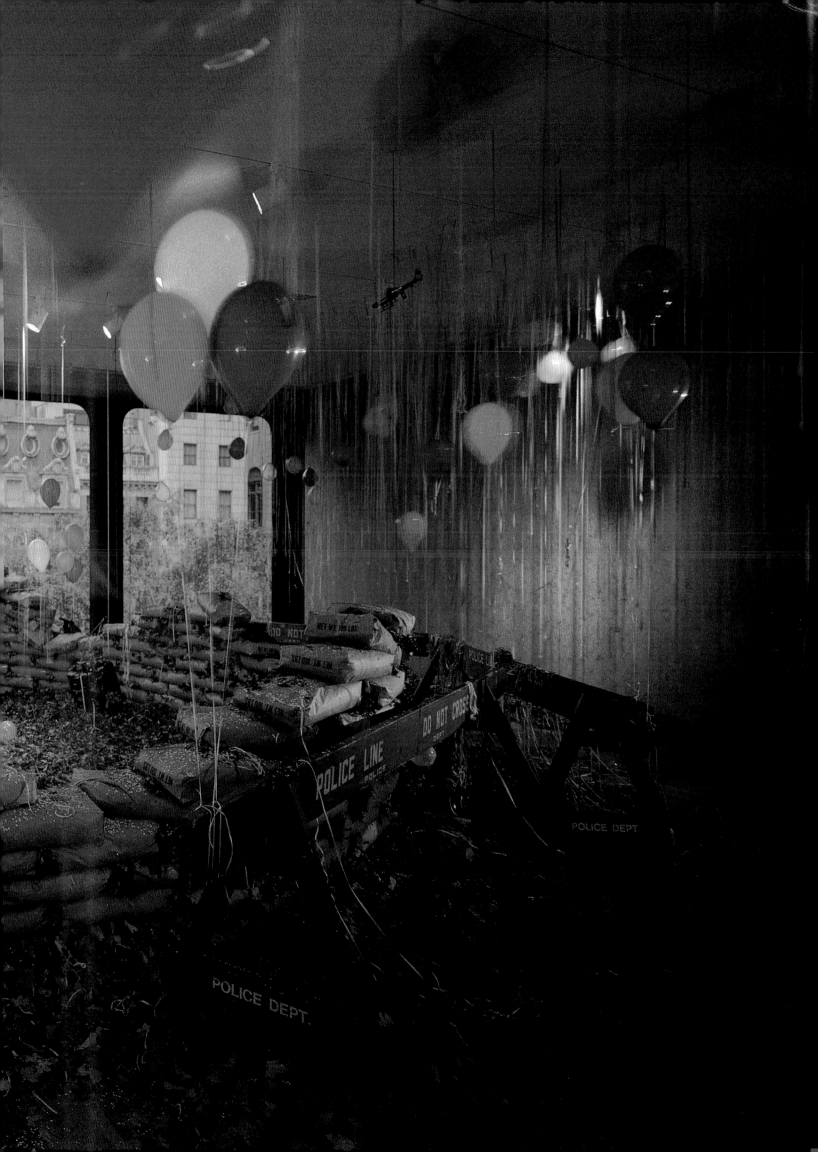

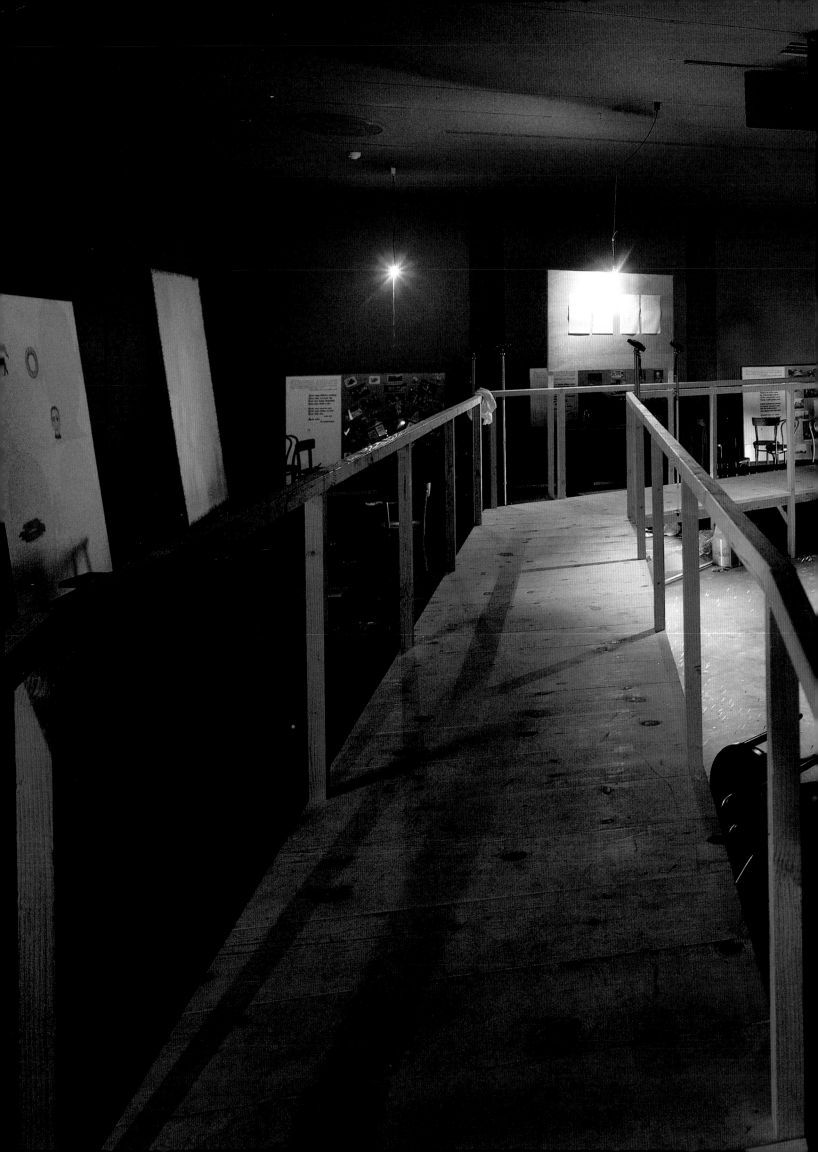

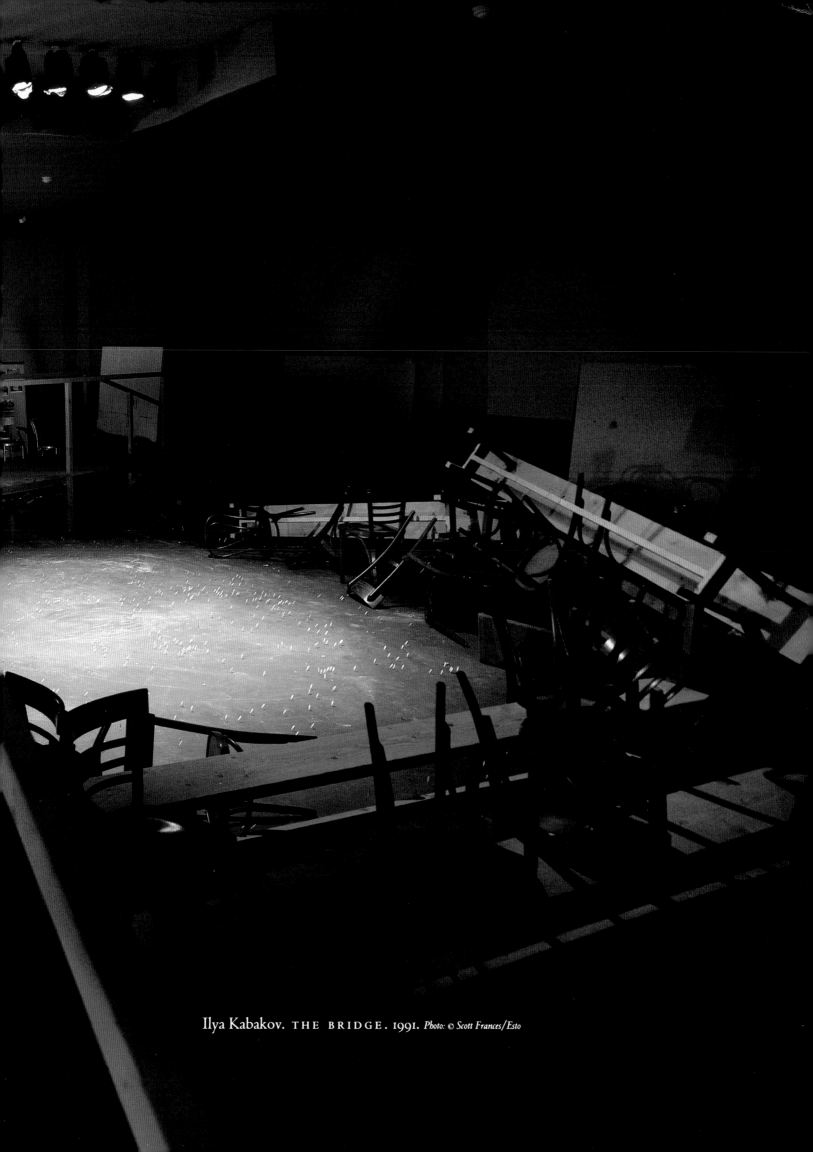

Ilya Kabakov. THE BRIDGE. 1991. *Photo: © Scott Frances/Esto*

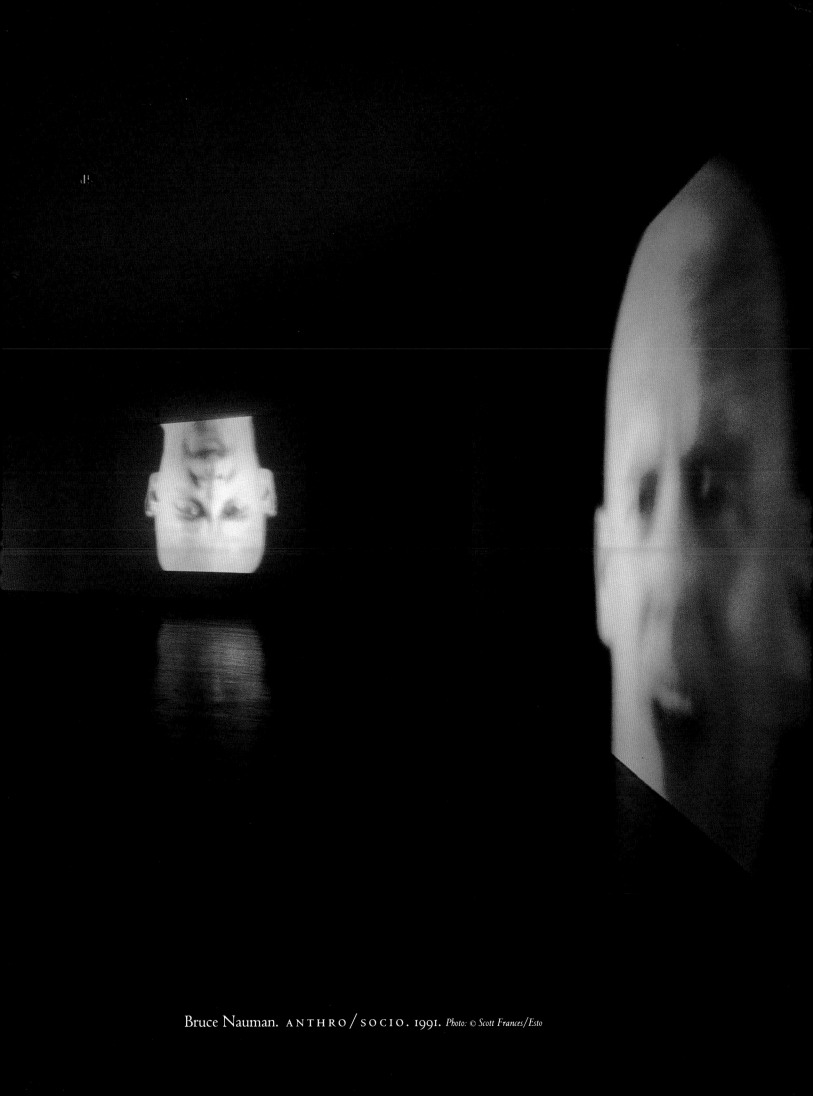

Bruce Nauman. ANTHRO/SOCIO. 1991. *Photo: © Scott Frances/Esto*

Adrian Piper. WHAT IT'S LIKE, WHAT IT IS, #3. 1991. *Photo: © Scott Frances/Esto*

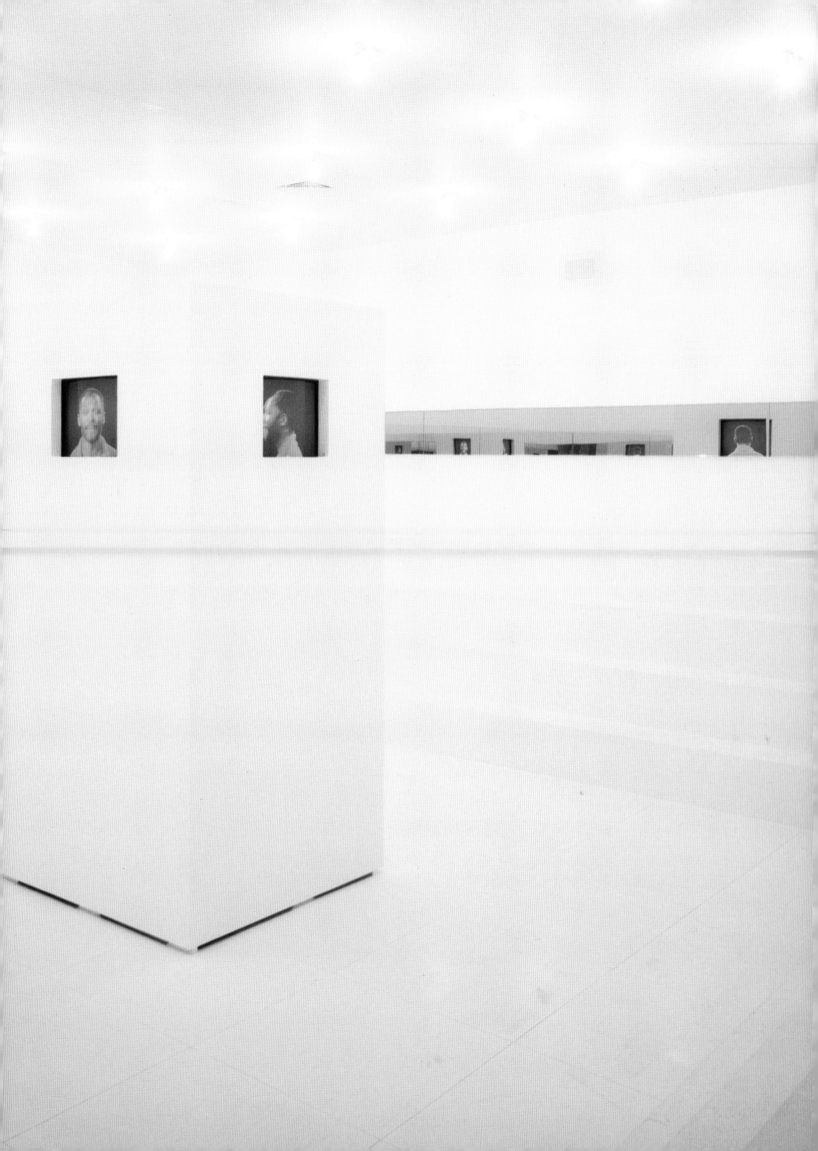

DISLOC ATIONS

ROBERT STORR

17 · XII · 91

FOR KIRK,

WITH WARMEST THANKS
FOR EVERYTHING — ESPECIALLY
FOR NOT TAKING "NO" FOR
AN ANSWER — Rob

THE MUSEUM OF MODERN ART, NEW YORK

Distributed by Harry N. Abrams, Inc., New York

WHERE ARE WE? There are plenty of reasons to wonder. And even more, perhaps, to ask why we don't wonder more often. Especially since the reference points we habitually rely upon to situate ourselves are so many and so easily mistaken for others bound to lead us astray. Most of the time we would just as soon pretend that we are sure of our surroundings, and, so, sure of ourselves and who we are. Rather that than pose the simple questions that might abruptly shatter the illusion of dependable normalcy. | The decision to enter unfamiliar territory means accepting the possibility, perhaps the probability, of losing our way. Travelers relish this state but most of us, even those who dream of foreign places, are cautious about striking out on our own—though getting lost in an armchair revery can be dangerous as well. Sometimes the decision to venture forth is made for us, and we wander about, unaware of our jeopardy. Plans for going "here" misfire and we end up "there," or nowhere that we know. The classic fable of thus being transplanted without warning is *The Wizard of Oz*. When Dorothy tells her companion Toto in a quavering voice, "I have a feeling we're not in Kansas anymore," her combined apprehension and anticipation hit a sympathetic but similarly ambivalent chord in the majority of listeners. | Parallel worlds like Oz serve double duty. They comment on and crystalize aspects of our own, all the while reassuring us that truly "there's no place like home." By which is meant the places whose rules we instinctively understand, heed, and endorse. But what of allegorical worlds that do not neatly reflect ours, worlds that cannot be reconciled to what we take for granted at "home"? Moreover, what happens when one steps outside one's usual environment, only to find that one cannot go back, or that once back nothing seems the same? The furniture has been moved, and the memory of its original configuration blurred. Every thing is off—slightly or drastically—with "slightly off" the most disconcerting of all possibilities. | Art may correct or heighten this sense of disorientation; in either case it transports us. That, at least, is the deeply though differently felt desire of most people, and it is far from inconsequential. To be moved by art is to be lifted out of one's usual circumstances and taken out of oneself, the better to look back upon the place one has departed and the limited identity one has left behind. With or without metaphysics, and for however brief a moment it lasts, this state may be fairly called transcendence. But where are we then? | The museum is the modern paradigm of such worlds apart. For some, its rooms enclose a higher spiritual region, in which case claims of transcendence may take on explicitly religious connotations. These spare and special precincts constitute a model for an otherwise unachievable human orderliness, as well

as the site for rituals of meditation and adoration. Housing altars to pure intent and certain "quality," they are the uncluttered shrines for art's contemplation. To this way of thinking, art is both vehicle and destination, with the museum a protected and protective domain in which the transposition takes place. Even when conceived of in entirely secular or materialist ways, the museum as sanctuary exists in defiance of the flux outside its walls.

Design variants of the museum and the gallery—which have become virtually interchangeable—are several, but nearly all revert to what Brian O'Doherty once and for all tagged the White Cube.[1] This austere box is the essential architecture for essentialist painting and sculpture. A three-dimensional pop-up version of nonobjective painting's purest two-dimensional examples, the White Cube is a container perfectly modeled upon the White (or otherwise flatly painted) Squares it was destined to contain. There, an ideally disinterested viewer confronts autonomous objects whose function is to focus the troubled mind. Extreme contingencies or mundane encumbrances are not permitted to pass the entrance to this rarified realm and so interrupt the mute exchange.

BY ROBERT STORR

The century has been unkind to such Utopian hopes, however. Neither the wholesale transformation of the world prescribed by social revolutionaries nor its formal reconfiguration according to vanguard blueprints has occurred.

These failures were anticipated or answered by some who modified the puritan version of the modernist program in its details but persisted in the hope of insulating art from worldly imperfections. Meanwhile, the poignant absurdity of such visions of a benignly rational modernity was always contested. Often the preferred terms used in opposition were pointedly unintelligible, raucous, mocking, or abrasive. A counterforce thus enters into the picture, and its material expressions occupy an uncertain and destabilizing place within the White Cube. Any account of modern art that leaves such a manifold tendency out is incomplete, just as any that for the sake of polemical convenience denigrates it as an awkward precursor, annoying sideshow, or decadent aftermath of high modernism is falsified.

Anti-art is immanent in Art-for-art's-sake, just as doubt shadows belief and protest answers doctrine. Modernism in its fractured fullness is the history of the minor upsets and major upheavals this dialectic has occasioned. Futurist performance and environments, Dada cabaret, Merz-rooms, Surrealist gallery installations, and their offshoots supposed a holism as absolute as that of transcendent abstraction but in every other respect antithetical to it. In these perplexing, if not alarming, counterrealities one thing did not lead to another, apparent cause did not produce logical effect, symbols did not match with or were not governed by their conventional referents. Nor was the gallery the orderly extension of its contents. Quite the opposite. Long before Allan Kaprow theorized Happenings as the spatial and temporal extensions of Pollock's turbulently overall canvases, artists were applying the radical compositional ideas they had developed in two-dimensional collage, montage, and paintings to three-dimensional spaces of every type.[2]

Dissent from the established order does not in itself guarantee the successful artistic expression of an alternative vision, of course. It is no easy matter to represent discontinuity or disfunction in a compelling way—no easier certainly than to make a plausible model of perfection. Especially given that what actually goes on around us often enough exceeds our most irrational fantasies, without mentioning our tolerance for either the reality or idea of chaos. Still, the two impulses—toward order and disorder—are inseparably linked. Inasmuch as the modernist notion of logical purity was conceived of in tension with a modern sense of confusion and unease, then the aesthetic ambition to stir misgivings or instill acute alienation corresponds to the longing for quiet, or constitutes a form of resistance to oppressive stasis and regulation. Successfully contradicting the essentialist view of modernity entails finding, if not the elemental terms, then at least the most direct and effective devices for evoking a world out of joint. If these devices are to describe a universe of myriad parts or extreme polarities they must be economical as well as apt, since concentrating one's attention on compound or contradictory images demands at least as great an effort as it takes to reduce experience to a single, coherent set of variables.

Mimetic in principle, such work offers a mirror to reality, but violates expectations by distorting, fragmenting, or editing the reflection it gives. Never, as so often charged, simply a gratuitous joke at the public's expense, modernism of this kind disturbs but does not muddy our vision. Instead,

1. *Inside the White Cube: The Ideology of the Gallery Space,* by Brian O'Doherty, Lapis Press, Santa Monica and San Francisco, 1976, 1986, p. 91.
2. "The Legacy of Jackson Pollock," by Allan Kaprow, *Artnews,* October 1958, pp. 24–26.

it sharpens the focus. Transgression is thus ever ready to spring the trap on transcendence. Eager to be transported, one can abruptly find oneself thrust through an anything-but-juvenile Looking Glass. The central image may or may not hold—for reasons one may or may not easily divine—but around it, as within it, incongruity, disproportion, and anomalous omissions and inclusions of detail are to be expected. Not due to sheer perversity of artistic intent, as the public is encouraged to believe by genteel philistines who dismiss vanguard provocations as incidental to or digressive from art's higher civilizing goal. And certainly not merely in order to distract the viewer from the world with fun-house diversions. On the contrary, the urge to displace or otherwise disorient responds to a still deeper desire to re-place and reorient.

Dislocation, therefore, implies calculated shifts of location and point of view and the indirect collaboration of artist and audience in mapping previously unimagined spaces, or remapping those taken for granted as self-evident. Such public involvement is demanded in the exhibition, since the artists—Louise Bourgeois, Chris Burden, Sophie Calle, David Hammons, Ilya Kabakov, Bruce Nauman, and Adrian Piper—have so carefully set the stage for our initial estrangement. All test our vision for impatient habits of observation and the reflex need for reassurance when confronted by unfamiliar circumstances or familiar but hard-to-endure causes of anxiety. Each requires the individual beholder to reconsider their identity in light of a given situation and the freedom or restriction of movement—hence, perspectives—imposed upon them within it.

As important as this loosely shared ambition, however, are the pronounced differences in intent, method, and motivation these artists act upon. To that extent, the show's organizing principle is at the same time a disorganizing principle. Mindful of the amount, but especially of the diversity of installation work currently being done, the aim here has been to bring together as wide a range of formal, poetic, and social practices as possible in such a numerically small sampling. Representing themselves rather than any tendency or generation or group, the artists and their work nonetheless mix origins, ages, purposes, and styles in a way that meaningfully complicates the attitudes and ideas they express individually, and so constellates a system of intricate connections and equally telling disjunctions. Spread throughout the museum, including the subtly changing "permanent" collection,

the works in the exhibition are for its duration linked to the many comparable constellations of the recent and not so recent past that fill the separate mansions within modernism's overarching house. One hopes that by their presence these works will highlight some of the connections between that structure and the world around it.

DAVID HAMMONS

Despite twenty years of activity, David Hammons has been until very recently a virtual stranger to the museum world, and remains indifferent to its house rules. The White Cube holds no magic for him. What is to some the laboratory of art, is to Hammons an arbitrary and ominously clinical environment, inhospitable to the lived forms he collects and transfigures. If it signifies anything, it is the challenge to find whatever manifestation of ordinary human vitality that has survived or can survive its antiseptic ambiance. Instead, Hammons has preferred the city as a workplace and its citizens as his audience and sometime co-workers. Street flotsam and jetsam are his materials. What he brings to the gallery is all and sundry that it traditionally excludes. What he extracts from those materials and brings to the objects and installations that he has created outside the museum are the marvels and mysteries that lie already and everywhere to hand along heavily trafficked thoroughfares, in public parks, and in the so-called vacant lots littered with the evidence of their constant nomadic occupation and use.

Impermanence is the governing fact of urban reality. Nothing stays anywhere for long, and nothing stays the same. Alertness to random possibility is the key to Hammons's various production, and that variousness testifies to the luck that favors the prepared mind of this scavenging artist. Accepting the transiency of metropolitan life as a working condition, and gradual dilapidation of one's art as its likely fate, is a bold but seemingly self-defeating stance. Numerous studio-based artists have made out-of-studio forays, but rarely has that option been adhered to so fully, for so long, or with such savvy equanimity as it has by Hammons. "I like doing stuff better on the street, because art becomes just one of the objects that's in the path of your everyday existence. It's what you move through, and it doesn't have superiority over anything else."[3] As a result, much of his work survives only in memory or in photographs. Besides

3. "David Hammons," by Kellie Jones, *Real Life Magazine* (Autumn 1986), p. 4.

his body-prints and paper pieces of the 1960s and 1970s—born in Southern Illinois and educated in Los Angeles, where he started to work, the artist came to New York in 1974—and his ongoing creation of smaller assemblages, some of Hammons's most important pieces have disappeared, among them, *Delta Spirit*, a collaboratively built beach cabana done in 1983, and the two versions of *Higher Goals* (1982 and 1986), telephone-pole-high and bottle-cap-adorned basketball hoops and boards placed in a Harlem lot and in Brooklyn's Cadman Plaza. Several of Hammons's indoor environments have also been broken up, for example, his untitled homage to composer and saxophonist John Coltrane and evocation of jazz' musical migrations in America done for the downtown space Exit Art.

Like jazz, Hammons's art consists of improvisations on a repertory of themes. As often as not, it cues into and off of the intuitions and energies of his temporary collaborators, be they builders, sidewalk supervisors, or musicians. Even with a long lead time or a complex project, the artist prefers to make it up as he goes along on site. Such was the case for this exhibition: various proposals were discussed during the year that has preceded it, but until Hammons arrived for the actual installation all options remained open and the result wholly unforeseen. Largely constructed or composed out of found objects and leftover substances, Hammons's work constitutes a reclamation project of sorts. Like Surrealist assemblage, his method thus fulfills the role of revaluing discarded artifacts by recombining them with other eccentric and unwanted bits of debris. Yet, inasmuch as Hammons secures an at least temporary place and purpose for things dislodged from their original locations or function, his particular choice of materials is predicated on a cultural rootedness equal to their physical rootlessness in the hard city setting.

The culture in question is that of Americans of African descent. A short index of the things Hammons conjures with includes: bottles, bottle caps, paper bags, fried chicken wings, coat hangers, cigarettes, old cloths, boom-box radios, records, tires, hair. Each has a "spirit" already in it, Hammons has said, and each invokes yet other spirits in the manner of its redeployment.[4] Bottle caps are applied to poles and woven into shredded tires like cowrie shells in traditional African craft. The tens of thousands of bottle caps he has thus incorporated were retrieved from Harlem bars by the artist.

Moreover, Hammons noted, "a black person's lips have touched" every bottle from which they came, and every one that he recycled to make his bottle-brick fences and coils.[5] The street-wise recognize them for what they are: empty pints of Night Train, poor people's wine of "choice." Unmistakably emblematic of the African heritage are the twists and clumps of hair Hammons collects from barbershops and binds into or glues onto wire, paper, rock, and elephant dung—the latter harvested from Brooklyn's Prospect Park Zoo. "I first saw hair on some African sculpture in the Chicago Art Museum [sic]," Hammons recalled. "I decided that that was the essence of African culture. You look at that hair: no one can have that hair unless you're African. That was my common denominator to making purely African art. People of color have wooly hair."[6]

In this and many other ways, Hammons's work, including *Public Enemy*, his piece for this exhibition, identifies and identifies itself with a people omnipresent in the United States, yet constantly overlooked or pushed to the margins. Hammons's elusive ubiquity makes an argument and stakes a claim on their behalf; he is the everywhere and insistently *visible* spirit of Ralph Ellison's Invisible Man. Working uptown in Harlem, across the river in Brooklyn, and downtown on the Battery beach or on Saint Mark's Place, the artist has taken the measure of New York and made his whimsical but uncompromising persona known throughout. This hit-and-run strategy has an urban guerrilla aspect, but, instead of attacking the already scarred city, Hammons embellishes it, leaving behind lyric reminders of the richness of African-American culture and of its healing powers. A product of that culture and of the streets in which so much of it has been nurtured, Hammons's sensibility thrives on harsh realities ignored by many but at their own risk, since as they worsen in neglect the peril posed to all only increases. "The reason I love New York is that the social conditions are so raw. You don't have to guess what's going on," Hammons has said.[7] When he sets to work, having exposed himself to that rawness, "all of the things I see socially—the social conditions of racism—come out like sweat."[8]

Among the challenges facing Hammons—and anyone who understands him—is to confront racism and the violence it gives rise to and turn them around, thereby enlisting destructive energies in constructive causes. A case in point: in 1988 Hammons painted a blond, whiteface

4. "Art People: Hammons's Visual Music," by Douglas McGill, *New York Times,* July 8, 1985, p. 15. | 5. "David Hammons," by Kellie Jones, p. 4. | 6. "Tragic Mask Sparks Hammons Retrospective at P.S. I," by Charlie Ahearn, *The City Sun,* January 16–22, 1991, p. 25. | 7. "Issues & Commentary II: Speaking Out: Some Distance to Go . . ." *Art in America,* September 1990, p. 80. | 8. Ibid.

likeness of Presidential candidate Jesse Jackson, with the caption "How do you like me now?" and placed it in the heart of a black section of Washington, D.C. Taking the piece as an affront, some men from the neighborhood knocked it down with sledgehammers. Exhibiting the piece two years later in his retrospective, the artist left the dents and made a foreground fence of hammers. A critical reflection of racist stereotypes, the image had been additionally charged by the hostility vented on it—a hostility provoked by the very racism it accused. Both the portrait and the hammers "represent the anger felt by blacks," Hammons said. "They didn't smash it. They anointed it."[9]

Work that makes its ties to a specific community so clear risks being dismissed by the uncomprehending as narrowly addressed to that primary community or merely typical of it. No such ghetto encircles or confines Hammons. As local as his aesthetic is, it is also cosmopolitan; Antonio Gaudì, Marcel Duchamp, Federico Fellini, and Simon Rodia, self-trained architect of the Watts Towers, are all acknowledged influences. Hammons's junk-amalgams also bear comparison with Rauschenberg's *Oracle* or his early Combines. Each of these examples exudes the atmosphere of its particular place and moment—fin de siècle Barcelona, Paris and New York of the teens and twenties, postwar Italy, the anarchically expansive City of Angels at midcentury, or New York in the sixties. Hammons's work does the same. With this distinction: he never stands still and he travels light. Setting out from 125th Street in Harlem, Hammons has given himself a roving vantage point from which to view the larger world. As he shifts ground, however, the markers he leaves behind always direct our attention to his point of departure, in effect daring us to take the A Train and retrace his path to its accessible but still more distant African origins.

ILYA KABAKOV

Ilya Kabakov's world is as cramped as Hammons's is wide open and far-flung. At any rate, that is the first impression. Both are dense with humanity, both subsist on scraps. "For us, the art lies here on the streets," said Kabakov of the Soviets of his generation. "It's not the artistic tradition but daily life that brings new ideas."[10] "No garbage is more or less important, it is all midportant."[11] In perfect agreement with Hammons's on this, Kabakov's attitudes are native to

a very specific situation. Little is gained and much is obscured by drawing hasty parallels between his work and that of conceptual or installation artists of the West, although Kabakov and his peers did have limited access to European and American art magazines, and for the past twenty years their work did on occasion mysteriously materialize outside the Soviet Union before the artists themselves were at all free to leave. Essentially Soviet in his attitudes and sources, this collector of refuse is by the same token a collector of souls in the tradition of Gogol. His universe—and it is a large one—is peopled by the myriad alter egos he has reconstituted from his sweepings. Or else, projecting his own multifaceted identity into and through these archetypes, he has provided them with rooms of their own in which to live out or reinvent their destinies. Often crammed together within the tight seclusion of a re-created collective housing project, these spaces are the frameworks of their existence and their self-portraits.

A much-looked-up-to elder *un*statesman of the Soviet avant-garde, Kabakov has been active since the mid-1960s. Born in 1933 into a poor and fatherless household, he matured during World War II and the worst period of Stalinist and post-Stalinist oppression. Trained from the age of ten to be an artist, Kabakov long earned his livelihood as an illustrator. Starting with stories by Sholem Aleichem, he has made drawings for over 120 published works, most of them for children. The fanciful but entirely legible graphic manner he developed for that purpose is the hallmark of his independent projects. Working the gap between writing and the plastic arts—but always leery of great literature and great painting—Kabakov is to a large extent a book artist, though hardly a bookish man. Prior to the mid-1980s much of his production consisted of boxed, loose-leaf albums, in which he would develop a single image or idea over pages of neatly rendered drawings and text. Each of these was a parable of or extended metaphor for the longings and constriction of contemporary Soviet life. Since that time, he has taken some of those themes and realized them as full-scale environments. Although different in conception, his omnibus *10 Characters*, for example, exists both on the page and as situational sculpture.

Installations seem to spring from his hand without hesitation, as if they had been slowly perfected in his mind long before there was any prospect of actually building them.

9. "Scorecard," *Sports Illustrated*, December 24, 1990, p. 14. | 10. "Ilya Kabakov: Profile of a Soviet Unofficial Artist," by Katrina F.C. Cary, *Art & Auction*, February 1987, pp. 86–87. | 11. "The Man Who Flew Into Space," by Robin Cembalest, *Artnews*, May 1990, p. 178.

When invited to do a piece for this museum, the artist briefly reconnoitered the galleries and then quickly detailed his proposal in a notebook. Between that sketch and the final work, he made no major changes.

Common to his work in both two- and three-dimensional formats, besides a melancholy humor, is an uncanny ordinariness. As remote as its historical context and as alien as its decor, this completely imagined world induces an immediate suspension of disbelief. Well-worn or desperately homemade, everything that awaits us seems to have been there a long time, imbuing the atmosphere with a comfortless nostalgia. The clock has stopped for these orphaned objects and vacant chambers, and it stops for us as well.

Making sense of the illusion that we so readily accept is difficult, however, since the situations and protagonists depicted are not merely foreign but intrinsically absurd. Kabakov's dissent is thus slyly insinuated into a skewed naturalism. Rather than overtly caricaturing official Soviet art in the fashion of younger artists such as the émigré team of Komar and Melamid, Kabakov has turned its conventions inside out with an almost affectionate regard for their stolidly prosaic inadequacy. Some years ago, Georgy Lukacs argued that instead of being its antithesis Solzhenitsyn's fiction signaled the long-delayed fulfillment of the Socialist Realist program. For different reasons in a very different time, Kabakov has fused that aesthetic to countertendencies represented by Bulgakov and the others in that long Russian line of satirical metaphysicians and mystics, producing a kind of Socialist Surrealism at once grim and magical, down-to-earth and otherworldly.

The Bridge has elements of both. As Kabakov explains in his notes for the project, installation as a medium permits the sharp juxtaposition of seemingly incompatible artifacts and symbols, and therein lies its attraction. The basics are simple. From the utilitarian furniture that crowds the room, to its plain doors and stark lighting fixtures, Kabakov's reconstruction of The Tenants' Club of Moscow Housing Project No. 8 gives one a sense of the dreary mediocrity of Soviet society. Nothing is spared his precise, unsentimental attention. This unwelcoming gathering place has been set up for an official lecture on the demerits of unofficial art, examples of which are propped against the drab gray walls between oxblood banners. Although the work of artists outside the system, the paintings nonetheless exemplify some of the bleakness and awkwardness of mainstream Soviet life to which they are the oppositional exception. Meanwhile, something has happened to disrupt the meeting, and viewers are invited to look down, from the boardwalk that inexplicably traverses the hall, at a massing of tiny white figures that appear to be the cause of that disruption.

Who these intruders are is never said. Impossible to make out individually, they are nonetheless oddly imposing. In part that is a result of their number and spotlit centrality. In larger part, though, it is a function of their mysterious but hinted origins. Minuscule and ephemeral, these featureless white "everymen" are emanations from the vast and even more featureless white void that envelops and occasionally opens into Kabakov's otherwise claustrophobic architectures. Warrenlike, those habitations are not just nightmarish improvisations of collectivization. They also protect their dwellers from being cast adrift in the still more terrifying wastes of a nation forever tearing itself down to build itself up. But even as they are sheltered from this no-man's-land, the blinding white vacuum beckons Kabakov's characters, promising escape from their mean quarters. Although represented by flat white-paper cutouts, this emptiness is a dynamic volume.

Playful as it is at times, and now imperceptibly circumscribed by the summer revolution in Moscow, Kabakov's art is in its context as pointedly political as any being made today. It is also a positive demonstration that if such art is to powerfully address social conditions it must first and finally excite the imagination. Poetic reference to a snowbound and eternal Russia, ambivalent commentary on Bolshevism's failed Utopia, Kabakov's fathomless and active emptiness is at the same time metaphoric of a universal existential dilemma. All who are subject to its conflicting terms experience their incommensurable imperatives as a constant tug between movement and inertia, vibrant hope and numb despair, turmoil and regimentation. Implicit in the Sublime, accordingly, is an equally boundless Anti-Sublime. That is what Kabakov means when he writes, "Every person living here lives, consciously or not, in two dimensions, the first is 'construction' organization, the second, the destruction and annihilation of the first. Emptiness creates an atmosphere of stress, excitedness, strengthlessness, apathy and causeless terror."[12] Seeking refuge in burrows and islands of habitation, he continues, people "build bridges across emptiness.

12. "On Emptiness," by Ilya Kabakov, translated by Clark Troy, *Between Spring and Summer: Soviet Conceptual Art in the Era of Late Communism*, Tacoma Art Museum and The Institute of Contemporary Art, Boston, 1990, p. 55.

But these communications, all of these roads, paths, highways, rivers and railroads belong to a somewhat different form of emptiness and are in a certain sense the opposite of the life of islands, this fellowship of people swimming in emptiness."[13] The restlessness such alienation prompts is nonetheless positive: "One of the most important signs of life is flight, dislocation, driveness. The wind of emptiness carries off and blows residents from their burrows . . . admitting no delay, letting no one become rooted. Each person is provisionally present here, as if they have arrived from nowhere very recently."[14] Viewers who peer down from Kabakov's bridge at the jumble around them and the delegates of emptiness huddled and untouching beneath their feet participate in this uneasy condition. Poised between dull disorder and the ambiguously luring abyss, they are neither above nor beyond it all, but smack in the middle of the no-place at the core and periphery of Kabakov's cosmos.

ADRIAN PIPER

Adrian Piper describes a related predicament and insists that, whether conscious of the fact or not, the public shares it with her. An African-American woman of very light complexion, Piper occupies the all-but-untenable middle ground between Black and White. At worst, given America's history and habits, this means a zone between bitter adversaries; at best, for the time being, it is fraught with possibilities for hurtful misunderstanding. In either case the territory is ill-marked and its frontiers and extent unclear. Although her situation is unusual and specific—at once hereditary and socially preordained—the ramifications of her investigations into it are far-reaching indeed.

Piper's sustained exploration of this treacherous middle ground represents a confluence of personal necessity and firm artistic decision. Turning a blind eye and a closed mind to it is a common and to a degree understandable reflex, given the odds that curiosity will be repaid with a slap. All along, however, Piper has shown a predilection for ambiguous situations. Well before her work centered on problems of racial identity and self-identification, she was preoccupied by the criteria used to differentiate people and the unspoken limits set on their conduct. Having started as a minimalist sculptor in the late 1960s, the artist's early conceptual experiments were unconcerned with social issues.

"As far as the work goes, I feel it is completely apolitical," she told Lucy Lippard in a 1972 interview.[15] The question she asked at the outset was simple: "How are people when you're not there?" An implicit corollary was: "What are the boundaries of personality when one carries on as if *they* were not there?" As a response, Piper devised a series of actions she performed on public buses: talking to herself, for example, or—the opposite—stuffing her mouth with a cloth. In either case she proceeded as if nothing she was doing was out of the ordinary, all the while closely monitoring the effects of her behavior on others and on herself. Her cultivated eccentricity was far from gratuitous, and so, despite its outward appearance, far from Dadaesque provocation. Although she adhered to the principles of Conceptualism as set forth by Sol LeWitt, who maintained that "irrational thoughts should be followed absolutely and logically," Piper differed from her friend and colleague in that she was not a "mystic," but a strict rationalist in search of demonstrable truths. Pitting logically determined misconduct against illogical decorum, her performances were less instances of anarchism or purely aesthetic speculation than of a philosopher testing a hypothesis.[16]

Inevitably, the question of how people are when you're not there raises the follow-up question of why they may refuse to see you when you are. The issue's significance and awkwardness increase as it becomes apparent that the reasons for refusing to recognize someone's presence can be linked precisely to the attributes that make them stand out. Not paying attention to a woman on a bus with a rag in her mouth—or, nowadays, a woman in rags—takes a special effort. Not identifying the woman you are speaking to as "black" because her skin appears to be "white" is a subtler matter, but it may require a similar denial that entails unpleasant consequences for both parties. In 1986, after repeatedly finding herself in situations where people made racist comments, apparently unable to discern her heritage or unwilling to believe that someone who looked like her and mingled in their setting could be "black," Piper responded by printing up a calling card she then handed out to ignorant offenders. It reads as follows:

Dear Friend,

I am black.

I am sure you did not realize this when you made/laughed at/agreed with that racist remark. In the past I have attempted to alert white

13. Ibid., p. 56. | 14. Ibid., p. 59. | 15. "Catalysis: Interview with Adrian Piper," by Lucy Lippard,
reprinted in *From the Center: Feminist Essays on Woman's Art,* E. P. Dutton, New York, 1976, p. 170. | 16. "Sentences on Conceptual Art,"
by Sol LeWitt, reprinted in *Sol LeWitt,* edited and with an Introduction by Alicia Legg, essays by Lucy Lippard,
Robert Rosenblum, and Bernice Rose, Museum of Modern Art, New York, 1978, p. 168.

people to my racial identity in advance. Unfortunately, this invariably causes them to react to me as pushy, manipulative, or socially inappropriate. Therefore, my policy is to assume that white people do not make these remarks, even when they believe there are no black people present, and to distribute this card when they do.

I regret any discomfort my presence is causing you, just as I am sure you regret the discomfort your racism is causing me.

Sincerely yours,

Adrian Margaret Smith Piper

The strategic poise Piper maintains in the face of casual bigotry is consistent with the basic thrust of her thinking. Wounded rage, the natural response to such an affront, she sublimates into stern civility. A product of the will and of the mind, this patient, didactic persona is her praxis and the form of her content. Rather than accommodate others, the artist's severe politeness affirms their existence, flaws and all, and demands of them full reciprocity. At issue is the ever-treacherous gap between appearance and reality, reflex response and reasoned conclusions. Regardless of the medium she chooses—since 1967 Piper has worked in performance, texts, sound, drawings, photomontage, and installations—the set of problems she addresses remains the same: at what threshold do people perceive difference? under which circumstances do they admit to it? where does your physical or psychic space end and mine begin? is there any such space that we share?

Perversely, the fact of racism is one of the key things we in this country have in common: the borderline of "blackness" as it is generally understood is the borderline of "whiteness" as well. In a mixed and miscegenating society, no one can claim to know its exact location. Piper's unfixable place in that polarized schema is empirical proof of the schema's failure to describe reality. Her decision to make her "blackness" public thus serves not merely to warn whites of her critical presence but to remind them that, given this nation's history, their own racial makeup may be subject to question. And even if it were assured, the logical and moral imperative to recognize and reject prejudicial stereotypes remains a general obligation and hence a bond among citizens of all ancestry. "If I chose to identify myself as black, whereas you do not," Piper explained in her 1990 video installation *Out of the Corner*, "that's not just a special fact about me. It's a fact about us. It's our problem." "It's not your fault," read several of her most recent photomontages, referring to the suffering and strife they depict alongside images of comfortable middle-class life, "but it is your responsibility."

Ultimately, any system based on bloodline percentages or categorical distinctions of skin color is absurd. In every way injurious to individuals and to society, racism is, not least, an offense to reason. Piper, a trained and practicing philosopher as well as an artist, and in that unique among her conceptual peers, pointedly instructs us that rationality cannot blandly coexist with irrationality, nor can it survive in a vacuum. Those propositions are the focus of her contribution to this show. The third in a series of recent installations, all with the same title, *What It's Like, What It Is, #3* consists of a tiered geometric structure reminiscent of minimalist sculptures of the 1960s and 1970s. In the middle stands a tall box, each facet of which frames a video screen. Together, as if in three dimensions, they show the face, back, and left and right sides of a black man's head. The litany he enunciates and denies represents a partial list of negative characteristics ascribed to his "kind." "I'm not pushy," he says, "I'm not sneaky, I'm not lazy, I'm not noisy, I'm not vulgar, I'm not rowdy, I'm not horny, I'm not scary, I'm not shiftless, I'm not crazy, I'm not servile, I'm not stupid, I'm not dirty, I'm not smelly, I'm not childish, I'm not evil." As he speaks, his head turns and his gaze sweeps the pristine amphitheater, staring back at those that stare at him, as well as at his own mirrored image on the surrounding walls. From all sides come music and, faint behind it, the noise of a crowd, vital and vastly bigger than the one in the room: it is the sound of the populous and motley world beyond.

In other words, at the center of the White Cube stands a "black" victim of offhand insults and arbitrary classification. These incompatible terms—the reassuring order of Platonic forms and the intrusive Other whose identity hangs in the balance between hard-lived fact and oppressive fiction— define Piper's dilemma and ours also. Were it not a question of race, but of sexuality, or class, or of whatever kind of desire brutally conflicts with actuality, the tension between transcendent aspirations and the weight of the human condition would be the same—and the sadness, since the damage done is to those who have every right to think, imagine, and act without prior constraint. On that score, Piper shall have the last words, from a recent autobiographical essay; counterposed to those of Hammons, Kabakov, and other artists in the show, their sense, already large, becomes larger still.

Abstraction is flying. Abstracting is ascending to higher and higher levels of conceptual generalization; soaring back and forth, reflectively circling around above the specificity and immediacy of things and events in space and time. . . . Abstraction is also flight. . . . Abstraction is freedom from the socially prescribed and consensually accepted. . . . Abstraction is a solitary journey through the conceptual universe, with no anchors, no cues, no signposts, no maps. . . .[17]

Until the racial tensions plummeted Piper back to earth, this was her unrestricted intellectual and aesthetic domain. That fall was triggered by the anxiety of whites, and while accepting its direct consequences, Piper does not disown her past revery nor concede its future return.

Each of [their] responses—fear, fantasy, mistrust, suspicion, anger, confusion, ignorance—obstructs my self-transcendence, my ability to lose myself temporarily in the other, in the world, in abstract ideas. These are the barriers my art practice reflects, because they are the ones that keep me grounded. . . . I am no longer drunk on abstract theory, because the sobering facts press in on my daily life too insistently. . . . So partly by my own choice, partly by accidents of my birth and position in society, I am cornered, hemmed in, somewhere in the basement of the building, preparing to crash my way out. My art practice is a reflecting mirror of light and darkness, a high sunny window that holds out to me the promise of release into the night.[18]

CHRIS BURDEN

"Pretend not to know what you know" is a recurrent text in Piper's latest work. Verifying what we know firsthand against what we know intellectually has been Chris Burden's long-standing project. Of a generation with Piper—Burden presented his first performances in 1971—the latter artist is the more empirical of the two. Initially his body was the prime tool of research, and he put it to extreme tests. Most infamous was *Shoot*. Curious to know what it was like to be shot, Burden stood in front of a gallery wall and had a friend put a .22-caliber bullet through his arm. Other comparably painful or perilous actions consisted of the artist strapping himself to live wires in such a way that a small mishap would complete the circuit and electrocute him (*Prelude to 220 or 110* [1971]), of his lying corpselike next to a car parked close to street traffic (*Deadman* [1972]), of his crawling almost naked across shards of glass (*Through the Night Softly* [1973]), and of his being nailed Christ-like to a Volkswagen (*Transfixed* [1974]). For *Five Day Locker Piece* (1971) Burden

curled himself up into a 2' x 2' x 3' space for the duration of the performance; in *Bed Piece* (1972) he remained silent on a cot for twenty-two days. These were exercises in withdrawal and solitary endurance. *Shout Piece* (1971), in which he sat suspended above a gallery floor surrounded by glaring movie lights and yelled at unwary entrants, "Get the fuck out, get out immediately," and *TV Hijack* (1972), in which Burden interrupted a cable-television interview and held the host hostage at knife-point, were as confrontational as the earlier examples were withdrawn or masochistic.

Whether he was acting out violence or directing it toward himself, the reasons for and discipline necessitated by Burden's early works were the same: transforming ideas and images into crucibles, Burden wanted to touch raw nerves. The artist's habit of putting himself and others in actual harm's way also puts Burden directly at odds with the "simulation" theorists of the 1980s. For the latter, the world exists only as a composite of simulacra or representations; for Burden the body is a conceptual medium, not a concept. Instead of shocking the public's sensibilities, Burden sought to jolt its senses so as to activate being and consciousness simultaneously. The threat of danger or discomfort ceased to be an aesthetic or symbolic gesture and became a jarring event, for which the artist prepared himself mentally and physically.

Naysayers and thrill-seekers forced Burden to revise his tactics, however. As with other kinds of situational art, one really had to be there, but few people were, and among them even fewer reliable witnesses. Except for the artist's own terse accounts of each action, and a certain amount of art-world commentary, the literature around Burden's performances tended predictably and discouragingly to the extremes of ridicule or sensationalism. On the one hand, then, he was dismissed as a preposterous art-*fakir*, on the other, he was cheered on as a vanguard daredevil. Newsweek critic Douglas Davis dubbed him "the Evel Knievel of art."[19]

From the late 1970s onward, Burden diversified his means, producing objects, machines, assemblages, collages, and artist's books. Whatever format he chooses, he continues to literalize ideas, particularly institutional or political attitudes normally taken for granted. Invited to make a work for the Wadsworth Atheneum in 1985, Burden constructed a pyramid of gold ingots worth exactly one million dollars, and surrounded the decidedly *arte-non-povera* construction with "armed" matchstick guardians. That same year he installed

17. "Flying," by Adrian Piper, in *Adrian Piper: Reflections 1967–1987*, curated by Jane Farver, Alternative Museum, New York, 1987, p. 20. | 18. Ibid., p. 24. | 19. "Wrestling the Dragon," by Suzanne Muchnic, *Artnews*, December 1990, p. 128.

Samson at the Henry Art Gallery in Seattle. Consisting of a turnstile connected to a mechanism powering a jack that drove two massive pressure-plate-capped timbers against the outer walls of the museum each time a patron entered, Burden's "exhibit" measured traffic by increments that would eventually precipitate the collapse of the museum itself. Burden's 1986 excavation of the floor and concrete footing of Los Angeles's "Temporary Contemporary," *Exposing the Foundation of the Museum,* was a similarly ambitious and even more obvious act of cultural undermining. Apparently fulfilling alarmists' worst fears of aesthetic subversion, the work allayed them at the same time. After all, both institutions still stand, and the usual business of art goes on inside.

To Burden's way of thinking "deconstruction" is scarcely word-play: it's a contracting job. The artist voiced the implicit questions posed the White Cube by these two projects in a recent interview. "Is the museum a pretty thing, a temple to architecture?" he asked rhetorically. "Or is it just a tin shed whose only value is to keep the rain off the art?"[20]

Far harder to objectify and so demystify than the symbols of cultural authority are the abstractions used to apportion political clout. In an international balance of power based on mutual deterrence, all the contenders calculate their relative advantage—or disadvantage—in stockpiled weapons. Generals and arms dealers persuade the public that there is safety in numbers, but after a certain point the numbers surpass comprehension. If so many bricks of gold equal a million dollars, how many submarines—paid for by how many million millions of dollars and pounds of gold—make up the American fleet? Or, to get an accurate measure of the former Red Menace, how many tanks could the Warsaw Pact field? These are the mathematical war games played in earnest at the Pentagon and the Kremlin, and they are the war games restaged in miniature with typically deadpan simplicity by Burden. To answer the first question, Burden fabricated 625 cardboard subs and hung them on transparent filaments like a school of lethal goldfish. To answer the second, he ranked 50,000 nickels topped by 50,000 matchstick "cannons" and entitled it *The Reason for the Neutron Bomb,* since it was then the assertion of American planners that a vast mechanized army required the development and manufacture of these tactical nuclear weapons.

In each of these demonstrations, as in his other military follies—for example, the immense toy-soldier Armageddon,

A Tale of Two Cities, or the recent design for an ecologically sound, sail-driven destroyer—Burden has remained neutral. Neither an avowed pacifist nor declared partisan, he is fascinated by the potential for violence but refuses to take sides. The politics of his work consists not in his approval or disapproval of the arms race or the ostensible justifications for it, but in his determination to render intelligible the huge scale on which preparations for war are constantly being made. "I'm interested in the gray areas, not black or white. I like to take something that people look at one way and turn it around and examine it from the opposite direction. When I did a piece on the neutron bomb, that didn't necessarily say that the neutron bomb was a bad thing."[21] But he added, "I kept thinking, 50,000 tanks, what the hell is that? Did they drop a digit? Add one too many? It's an abstraction rather than a real thing, and my fear is that people make those kinds of decisions in a very abstract way, like the B-52 pilots who used to eat lunch while dropping bombs over Hanoi: they couldn't see or hear the bombs go off so it wasn't real to them."[22]

Conceived of seventeen years after the end of the American phase of the conflict and almost ten years after the completion of Maya Lin's Washington monument to our troops, *The Other Vietnam Memorial* is Burden's effort to make the full impact of our might real. Although the *Memorial* is a departure from his "gray-zone" projects because of the artist's stated opposition to United States involvement in Southeast Asia, the point of commemorating the Vietnamese dead is less a laying of blame than an accounting of the sheer magnitude of the slaughter in which we took part. At first much debated but now generally embraced by citizens of all political persuasions, Maya Lin's work lists by name every one of the American losses—the total runs to 57,939 men and women. The Vietnamese figure is vastly larger and ultimately unknowable. At a minimum, it comes to 3,000,000 dead during just the American episode of the generations-long Indochina war. Derived from conversations with journalist and historian Stanley Karnow, former members of the South Vietnamese government, and contacts with delegates of the present Vietnamese regime, this number includes some 250,000 soldiers and 1,500,000 civilians and refugees in the South, some 700,000 military dead and 250,000 missing in action in the North, plus estimates of civilian losses in the North and along the heavily embattled border regions. Exact

20. "Taboo Hunter: A Current Chris Burden Survey Demystifies the Demystifier," by Ralph Rugoff, *L.A. Weekly,* April 22–28, p. 43. | 21. "Wrestling the Dragon," p. 126. | 22. "Taboo Hunter," p. 43.

records equivalent to those kept by the Pentagon are not available from the various Vietnamese sources, although its own losses are remembered by virtually every family on both sides. As a result, Burden's monument is intrinsically different from Maya Lin's.

In order to register the 3,000,000 casualties he was obliged to take a basic catalogue of nearly 4,000 Vietnamese names as verbal integers and permutate them. A degree of abstraction necessarily persists. Even so, the war that so many want to consign to the past has never been more actual, with the enormity of the bloodletting at last represented *in toto*. Reckoning the gross facts of history in terms of the fate of individuals, Burden's *The Other Vietnam Memorial* thus partially retrieves the Vietnamese dead from statistical purgatory and so from a double disappearance: the 3,000,000 it symbolically lists are the displaced persons of the American conscience.

SOPHIE CALLE

Absence and fleeting presence obsess Sophie Calle as well, but for her they are mundane, rather than epochal, contingencies. Like Piper, she is interested in the point at which awareness of others is reciprocated, then becomes self-recognition. Like Kabakov she collects souls, though as often as not they are soon lost once more. In other respects, though, her images and narratives have an almost forensic quality, recalling the existential mystery stories of Marguerite Duras, Natalie Sarraute, or Alain Robbe-Grillet. For Calle, as for these veteran practitioners of the French "new novel," the smallest of details are closely examined, since none is so ephemeral that it may be discounted as an essential clue to the identity of an elusive author.

Calle's scrutiny can be direct and interrogatory, or it can be surreptitious and voyeuristic. In either case, the focus of her attention shifts constantly between objective inquiry and subjective musings, just as she may at any point shift roles from that of the watcher to that of the person being watched. The artist's conceptual, as well as literal, point of departure was simple enough. Returning to Paris in 1979 after seven years away from her home ground, Calle experienced a physical disorientation that triggered an even more profound sense of psychic alienation. "When I came back, I felt lost in my own city. I had forgotten everything about Paris. I had no habits, I didn't know anyone. I had no place to go, so I just decided to follow people—anybody. I became attached to these people, so I took a camera and made notes."[23]

At loose ends and with nothing but her affective compass to guide her, Calle became a geographer of displacement and an anthropologist of intimacy achieved or failed. Between April 1 and April 9 of 1979 she invited twenty-four people to sleep in her bed, one at a time, in rotation, questioning each in a neutral manner and photographing each at intervals during their rest.

Sleepers, also known as *Bed* or *Big Sleep*, consists of selected photos interspersed with brief transcripts of these conversations. In New York during 1980, she picked people up outside of The Clocktower and Fashion Moda—two alternative art spaces, the first in Manhattan, the second in the Bronx—and asked them to lead her to someplace that was important to them. On arrival she took their pictures and wrote down the explanations for their choices. In Venice the next year, she hired herself out as a chambermaid for a month, recording her activity as she made composite portraits of the occupants of the rooms she cleaned from snapshots of the things she found in their drawers and luggage. A spy in the house of banal love—in this menial capacity Calle not surprisingly walked in on a couple having sex—she later rode the less-than-romantic Trans-Siberian Express to Vladivostock and recorded the awkward understanding she established with a sixty-year-old Soviet man who shared the compartment (*Anatoli* [1984]). In Paris again, she came upon a man's address book lying on the sidewalk. Intrigued by her find and anxious to know more about its owner, M. Pierre D., she tracked down all those listed and interviewed them about the man, publishing the results in the Paris daily *Liberation*, from August 2, 1983, until September 4 of that year. For *The Blind* (1986), she asked twenty-three sightless people what their idea of beauty was and then juxtaposed photographs of their faces to photographs she felt were emblematic of their answers.

An intrepid spectator, Calle is an emotional speculator as well. Introducing herself physically and psychologically into unknown situations, she reconstitutes the character and feelings of others from scattered insights and materials gleaned during her alternatively considerate and prying inquiries. On occasion, Calle has relinquished the role of the observer and

23. "Surveillance on the Seine," by Andrea Codrington, "View," *The Journal of Art*, November 1990, p. 26.

placed herself under observation. This change from active subject to passive object repolarizes the erotic charge that is a more or less obvious but consistent part of her behaviorist poetics. For *Suite Vénitienne* (1980–91), she dressed in a blond wig, dark glasses, and raincoat and in that film-noir disguise pursued a man with whom she was casually acquainted from Paris to Venice and back to Paris. For *La Filature* (1981), or *Shadow*, she had herself followed by a private eye throughout the course of one day.

Being shadowed and being a shadow are two halves of the same transitory reality. Everything, this role-switching game seems to argue, depends on a stolen or studying glance. However brief or artfully contrived, encounters between herself and strangers, and encounters with herself via strangers, are testimony to her passage through space and time. Existence is verified by surveillance, and mnemonically preserved. Having once caught our attention, moreover, something out of sight or out of hearing is never finally out of mind. The most casual of contacts leaves its imprint, and endures in that imprint. This rule covers all things onto which or into which the individual imagination projects itself—including art.

Enlarging for this exhibition upon a single experiment made in Paris several years ago, Calle asked a cross-section of museum staff members what they recalled of several paintings that had been removed from their usual locations in the galleries. All of these painting were classics of their kind. One, Edward Hopper's *House by the Railroad*, was the first work ever acquired for the permanent collection. The personnel interviewed were selected to represent all levels of involvement with the paintings: curators, preparators, registrars, framers, conservators, and others who handled or otherwise had direct contact with the work. Also involved were guards and maintenance workers who frequented the galleries on a daily basis. Everyone was posed the same questions, and everyone, whether studio-trained or untrained, was requested to complement their oral description by making simple sketches of what they remembered. From these fragments a composite visual and verbal image of the missing work was arrived at and then laid out in its exact dimensions on the wall normally reserved for the "real" thing. Calle calls the substitutes that make up her installation *Ghosts*, after the French expression for the labels used to tell museum visitors where a painting no longer on view has gone.

Neither a sociological survey nor an art historical pop quiz, Calle's project prompts some subtly disconcerting thoughts regarding the separateness of cultural and individual memory. The substance and range of reactions Calle documented should, at very least, give pause to those who declare themselves to be sure of the import of such canonical pictures. Objective standards of aesthetic value are powerless to deflect the subjective impulses that abbreviate and transform images according to need or vantage point. Recollections of some participants read like the answers to a Rorschach test; given the subject matter of some of the paintings—Magritte's *The Menaced Assassin*, for example—this is altogether appropriate. In other instances, the statements seemed less focused on the art than on its extra-aesthetic associations. More than the idiosyncrasies of the responses, though, and more than the prismatic facsimile of the absent image, what one takes away from these fragile inscriptions and cursory drawings is a sense of the mutually affirming but unstable relation between the beholder and the thing beheld. Eventually, the paintings will return to their allotted spaces and the texts will be erased and the sketches removed. In the meantime, the ghosts on the wall are not so much those of the artists' handiwork as the specters of anonymous passers-by who lingered for a while in the White Cube, then moved on.

LOUISE BOURGEOIS

For over fifty years Louise Bourgeois has been giving shape to memory. Her childhood is the source of much of her imagery and all of her motivation. That was hardly an idyllic time for the artist, nor was her family a model one. But neither were the tense relations among its members wholly outside the norm. All things considered, the divided loyalties, hurts, resentments, and the frustrated quest for exclusive love Bourgeois recalls were typical of those inherent in the classic Oedipal dynamic of mother, father, and child. What is extraordinary is the severity of the psychic wounds Bourgeois endured and the consuming passion she has devoted to re-creating her past—not that doing so has resulted in happier endings for her stories. The reverse is almost always the case. Compulsively diagramming the permutations of the primordial family triangle, Bourgeois has invented multiple surrogates for each of its disaffected protagonists and played all the parts in rotation. Working out needy

ambivalence and furious anxiety toward the characters in this drama, Bourgeois has invested her changeling persona in effigies of an alternately implosive and explosive individuality and used it to symbolically confront icons of intractable otherness.

Bourgeois, still full of surprises, remains a thoroughly contemporary artist. The singularity of her work derives as much from its formal and material variety as it does from any particular innovation or image. Over the course of her career she has painted, drawn, made collages and assemblages, modeled in clay and plaster, carved in wood and marble, and experimented with latex and resins, often abandoning a process for years, only to return to it later with renewed enthusiasm and greater demands. Installation has been among her aesthetic preoccupations from the very beginning. Consisting of dozens of abstract "personages," Bourgeois's first two solo exhibitions at the Peridot Gallery, in 1949 and 1950, were both conceived of as environments. These vertical elements were paired, grouped, or spread out in loose proximity to one another. The arrangement appeared almost nonchalant, making their combined psychological effect all the more startling. Meeting the artist's freestanding figures on an equal but unsure footing—the sculptures were planted in the floor without bases—members of the public found themselves mingling with anthropomorphic shapes that leaned toward and away from neighboring pieces like guests at an interminable and enigmatic gathering. The presence of these listing, clustered forms made viewers acutely conscious of their own physical and emotional disposition, that is, their relative equilibrium, sensitivity to touch, and isolation.

After this debut, Bourgeois continued to mount shows in which the ensemble effect was crucial to the impact of individual works, but it was only in the mid-1970s that she began to make full-scale installations. The first of these, *Destruction of the Father* (1974), is a low cavern bathed in reddish light. Its ceiling is covered by ranks of breasts or phallic mounds, as is the floor, which is also littered with casts of animal haunches. Although one may well recoil from its biomorphic swellings and scattered butcher's scraps, the womblike hollow nonetheless beckons. That simultaneous attraction and repulsion is characteristic of Bourgeois's art, as are mixed messages of other, less physical, kinds. Surrounded in an ellipse by upright screens and low, cutoff

boxes, the central table of *Confrontation* (1978), with its rows of bulbous shapes, repeats the iconography of the previous piece. At its unveiling, Bourgeois organized what she called "A Banquet/A Fashion Show of Body Parts," for which performers donned latex sheaths sprouting similarly obscene lumps and bumps. Leveling her implacable feminine gaze on patriarchal and scholarly authority, Bourgeois gleefully enlisted a number of famous art historians into this festively androgynous masquerade.

The mood of recent installations has been more introverted. Like the contiguous wooden modules in *Confrontation*, the hinged panels of *Articulated Lair* (1986) frame an arenalike space, but the enclosure is reserved for a solitary occupant, with escape doors at either end in case of intruders. The environmental works in various states of completion now spread around her Brooklyn studio make use of a house-of-cards, or accordion, construction similar to that of *Articulated Lair*. Encircled by cast-off doors of every description, these cells contain meager and mysterious furnishings. In each, as in Kabakov's rooms, the phantom inhabitant is represented by secret amulets and soiled amenities. Eavesdropping through broken window panes or the cracks between the doors, the viewer may steal glimpses of these hermetic accumulations of detritus, and puzzle over the obsessive personalities they evoke.

Bourgeois's bulky and aggressive piece for this exhibition contrasts markedly with the delicacy of such fetishized spaces. Age has certainly not mellowed her contradictory nature; instead it has made her more ambitious and more experimental in its expression. Quick to see the possibilities in found objects on an intimate scale, her keen, pack-rat eyes scan the large horizons as well. In this case, inspiration came when she spotted several huge steel lozenges sitting next to the road. They were a few of the thousands of leak-prone gasoline storage tanks currently being excavated on orders from the Environmental Protection Agency. Assemblage, the artist has said, is a process of recuperation and restoration, a means of reestablishing order among exiled things that have lost their normal function. In this regard she and Hammons are at one. The satisfactions of the hunt, Bourgeois explained, lie literally underfoot in a mesmerizing urban chaos. "Now, for an artist, you well understand, this can be full of fantastic objects and you look at them and that is the beginning of the assemblage. It is a rescue mission."[24]

24. "Meanings, Materials and Milieu," by Robert Storr, *Parkett*, No. 9, 1986, p. 85.

Disowned by the industrial system that had created them, these rough, voluminous tanks represented a unique opportunity to turn obsolete technology to poetic uses. The artist promptly struck a deal to have several hauled away to her studio in Staten Island, where she could attend to them at her leisure.

The first step of Bourgeois's creative procedure typically involves choosing, or in the case of assemblage, taking possession of, her materials. The second step is to recognize a content latent in the particular form. Simplicity is the essence of both, but the resulting images are invariably polyvalent and complex. In this instance, Bourgeois associated the extended cylindrical form of the tanks with the low-lying Easton, Connecticut, house in which she, her husband, and her sons lived on and off during World War II and for a period thereafter. The row of windows and side entrance she cut into the tanks are characteristic of that family retreat. Episodes of intimate alienation are as much a part of that memory, however, as they are of memories of her growing up in her parents' household outside Paris.

The key to the formal logic and metaphoric significance of *Twosome* lies in a studio piece done in the mid-1980s. Made of lengths of ordinary pipe of decreasing diameters inserted into one another, this so-called *Nest* symbolizes the basic self-containment of each part of this neatly telescoped composite. It is a model of closeness and a demonstration of insularity: every section touches another at a single point, and all but the centermost surround one or more components, yet each remains essentially hollow and the whole does not fuse. Enormously enlarged and reduced to its basic relation, *Twosome* is otherwise much the same in its structure and import.

There are differences between these two pieces, though, and those differences further exacerbate the work's implicit psychological tensions. The programmed interaction of its two unequal halves elicits imaginative physical interaction with the viewer. Like the soft, biomorphic *Destruction of the Father*, the hard kinetic void of *Twosome* entices and wards off the bystander. Big enough for someone to crouch inside but difficult to enter, this chambered lair is at once a place to hide and—should the inner tank retract definitively into the outer one a—trap. Meanwhile, the automatic insertion and withdrawal of the small cylinder into the larger cylinder has obvious and ominous sexual connotations. Conflating

flesh and steel, instinct and mechanics, domestic architecture and body cavities, Bourgeois has invented an infernal self-impregnating and self-delivering machine for a Heavy Metal age. It is not, however, an erotic device, and certainly not a bachelor machine on the Duchampian plan. Bourgeois is a woman, not a man, and the imagined occupant of this two-celled structure is a presexual child baffled by the antithesis of adult masculinity and femininity and threatened by the repeated, exclusionary, physical union of its mother and father. For such fearful offspring, return to the protection of the maternal body is the ultimate wish. *Twosome* invites such fantasies, but taking refuge in either capsule is equivalent to climbing into bed with monstrously copulating parents. Grotesque and, to that extent, darkly humorous, Bourgeois's hollow contraption nevertheless echoes with a terrible loneliness.

BRUCE NAUMAN

Bruce Nauman leaves us nothing but room for doubt. And so, room for thought. Over the past twenty years he has framed structures, composed phrases, juxtaposed images, and compounded contradictions that put the viewer on the spot in ways that make one uneasily aware that the "spot" itself is shifting ground. Nauman's rhetorical questions have no ready answers; at least, the artist refuses to provide any. His environments, though often emphatically symmetrical, have no centers, none, that is, that one can occupy without feeling out of place or no place at all. Paradigmatic of all that followed, Nauman's first installation, done in 1972, resounded with a blunt demand: "Get out of my mind, get out of this room." The implication is plain—in his art, physical space and mental space are synonymous. The paradox posed is equally plain, for by shaping the former he offers access to the latter. Art-loving members of the public asking to be let into his imagination thus find that they enter at their own risk, since that love may not be reciprocated, while the other passions they discover may prove intolerably intense. Artistic hospitality, the voice insists, can be revoked at any time or may discomfit all concerned. "Pay attention, motherfuckers"—printed backwards—reads the text of a lithograph made a year after the 1972 installation. If one gets Nauman's meaning, one gets it coming and going.

Generally speaking—and literally speaking in the case of

Anthro/Socio, his piece for this exhibition—Nauman's art is a projection of frustration and ambivalence and the more or less overt hostility they provoke. Once asked about his affinity for Duchamp and Pop, Nauman explained that he was interested in work "where you used public means of communication for private purposes."[25] This said, the private motives and experience that lay behind his variform output are impossible to adduce from the fragmentary evidence it provides. In Nauman's work, as in that of Jasper Johns, whose sensibility parallels but also differs from his, personal factors are so elusively encoded that attempts to pin them down condemn one to misunderstanding. The author is unknowable, as are the psychological or intellectual causes of the anxieties and conflicts of perception he names. It is the naming of them and the constant state of being anxious that matter.

Expressive in the highest degree, and of many things—sexual tensions, global violence, moral uncertainty, and skepticism about the metaphysical claims of art—Nauman's art is never expressionist, that is, never merely declarative, despite its sometimes categorical use of language. Virtually every term or proposition appears in the context of its antithesis. Whether carved in stone in one version or emblazoned in neon in another, the seven cardinal virtues are, for example, superinscribed with the seven cardinal vices in a manner that leaves open the question of whether they have been pitted against each other or offered as a deadlocked and self-canceling unity. Far from being dandified in the Duchampian manner or glib as in that of much post-modernist art, Nauman's irony forbids one both easy choices and easy escape from choices.

Nauman's tone and mode of address change constantly, moreover. Conceptual severity and disturbing content are often presented in a comic guise. Punning has long been his practice, but recent videos have taken off-topic jokiness to new extremes, a jokiness all the more disturbing for undertones of peril. One featured a clown standing in an empty room holding a fishbowl with a live fish to the ceiling with a pole. Were he to move, the bowl would come crashing down on his head. Thus stranded, he stared at the viewer, plaintively asking for help that the viewer, of course, could not give. Making matters worse—and more absurd—several of the TVs on which he appeared were turned sideways and upside down so that the "gravity" of his predicament was reversed in a visual play on words. The piece is titled

Clown Torture (1987). Another tape showed a harlequinesque acrobat painfully contorting herself on a chair in response to curt off-camera commands. Elsewhere in the room wax heads hang on wires, and video images of the same head receiving the occasional whack of a board are projected on rudimentary canvas screens. Called *Shadow Puppets and Instructed Mime* (1990), this piece and others like it are droll and unnerving syntheses of Beckett, Bozo, and sadistic Guignol.

Nauman often reprises texts, situations, or characters this way, sometimes employing a single medium, sometimes alternating media. Meaning thereby accrues to a given idea or image by repetition and variation. Apparently indifferent to the issue of developing a signature style—Nauman has none or many, depending on how one looks at the many formats he has resorted to and his unique way of handling each—the artist is intent instead upon developing his thought wherever it takes him. The video installation created for this show exemplifies that process and its perplexing rewards. The script is based on an earlier text-drawing that said, "Feed Me/Eat Me, Help Me/Hurt Me." The equation of nurture and abuse, consuming need and being consumed recalls the ambiguities embodied in Bourgeois's self-devouring mechanism. Consistent with his present preoccupation with learned dependency, Nauman puts the issue in even harsher and more masochistic terms. Any plea for help is an admission of helplessness, these doubled imperatives imply, just as any admission of powerlessness in turn grants power to others.

When he adds the word "anthropology" to the first phrase and "sociology" to the second, Nauman introduces an explicitly social dimension to what might otherwise be a strictly intimate plea. Rather than "using public means of communication for private purposes," in this instance Nauman has reversed his strategy in order to root a public discourse in the private realm. The sciences of human conduct, sociology and anthropology, purport to give us exact knowledge of ourselves and so, presumably, reasonable guidance in improving our lot. Behavioral conditioning and systems of control and constraint belie such a benign expectation. Tainted by hubris inside the academy, outside it, social engineering is prone to totalitarianism. Voiced in at once plaintive and stentorian tones, Nauman's text articulates an old and basic fear that the rational powers we appeal to for help will turn on and destroy us. (His subtext might be construed as a retort to those who crib from such disciplines with the vain

25. *Bruce Nauman: Neons*, Brenda Richardson, Baltimore Museum of Art, 1982, p. 20.

ambition of logically resolving art's paradoxes.) Leery of the social sciences' present sophistications, Nauman's emerging view of the human condition—his recent neon friezes of sexual subjugation and general mayhem are further confirmation—is less skeptically post-modern than classically Hobbesian. "No society," Hobbes wrote of the state of nature, "and which is worst of all, continual fear and danger of violent death; and the life of man, solitary, poor, nasty, brutish, and short."

Wandering into and around the empty, penumbrous room of *Anthro/Socio*, the viewer is bombarded from every direction by calls for help emanating from multiple monitors and projectors. The solitary, unblinking head that intones Nauman's words in plain chant becomes a chorus and his short command a canon. Thus surrounded, it is impossible to stand still for long. In spite or because of the ambient noise, one finds oneself whistling in the mental dark. Long ago, Nauman credited Duchamp for having thought to substitute objects for ideas. Expanding on that precedent, Nauman substitutes environments for ideas as well. Regardless of the specific means, however, his intent is to trigger unprepared responses. Conceptually rigorous, Nauman is also emotionally exigent. Denied the possibility of taking a firm position on or in his work, his audience is forced to react. The intensity of that reaction invests the provocation with meaning, fulfilling the artist's basic demand that we *pay attention* to how it feels to be torn between extremes and on one's own.

AS DIFFERENT AS

these works are in design and appearance—and it bears repeating that the artists who created them were chosen for their singularity, hence their dissimilarity—they are all in some way demanding. Each requires that the individual viewer physically and psychologically enter into a space conceived in the image of instability or mystery or aggravated ambiguity. It is a lot to ask, since these are difficult times. But difficult times are the matrix of modernism. Although we have been promised a new order, major upheavals abroad take place daily, while cracks in the façade of domestic peace increase. All around us fault lines in the social terrain, matched by fissures in our consciousness, grind and shift and suddenly gape. Under these circumstances we may wish to take

flight—as Piper explained—but we can't. Or, cast adrift, we may look for shelter in burrows—of which the museum on occasion seems a capaciously chambered variant. Kabakov reminds us, however, that dislocation is a sign of life. Many of the hard truths and conflicting impulses we must contend with are familiar, yet their power to disturb is undiminished. History does not repeat itself, but neither will it go away; Burden in particular has shown that things that we thought were once and for all behind us now stare us in the face. Bourgeois, Calle, Hammons, and Nauman meanwhile express restlessness born of distinct and compelling causes that are less exemplary of the historical moment than of an acute, sometimes excruciating, alertness to the inconsistency and irresolution of everyday experience.

Such elusive states of being and such unforgiving contradictions are troubling; few artists these days have the Wordsworthian good fortune of recalling emotion in tranquility. So, too, looking at work of this kind means letting go of a measure of our security; still fewer members of the public can reflect on their experience at a comfortable distance. It takes an act of will for viewers to venture from the sidewalk into rooms that deliberately focus on some of the pressures they thought they were briefly leaving behind, only to plunge back into the tumult with a heightened sense of uneasiness. It also takes imagination, as does putting oneself in someone else's place to consider things from their vantage. Some of these installations assume our capacity to do the latter, others invite us into circumstances that are less public and didactic than private and evocative—even though the fact of our being there and in generally unknown company is itself social. None of these works are predicated on our coming to final terms with the issues they raise; none put our doubts to rest by offering solutions. To have done so would be a failure of imagination on the artist's part, and to single-mindedly seek such a way out would be a comparable failure on the viewer's part. Yet having reset our compass in order to navigate these strange spaces, and reground our lenses to adjust for their apparent distortions, we may find that on returning to "reality" we actually move about with greater freedom and see with greater clarity. Whatever the improvement on that score, like people exiting a theater, we will step back into the world, which for a moment at least will open out to us as freshly detailed and sharply various.

LOUISE BOURGEOIS CHRIS BURDEN SOPHIE CALLE DAVID HAMMONS ILYA KABAKOV BRUCE NAUMAN ADRIAN PIPER

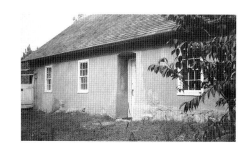

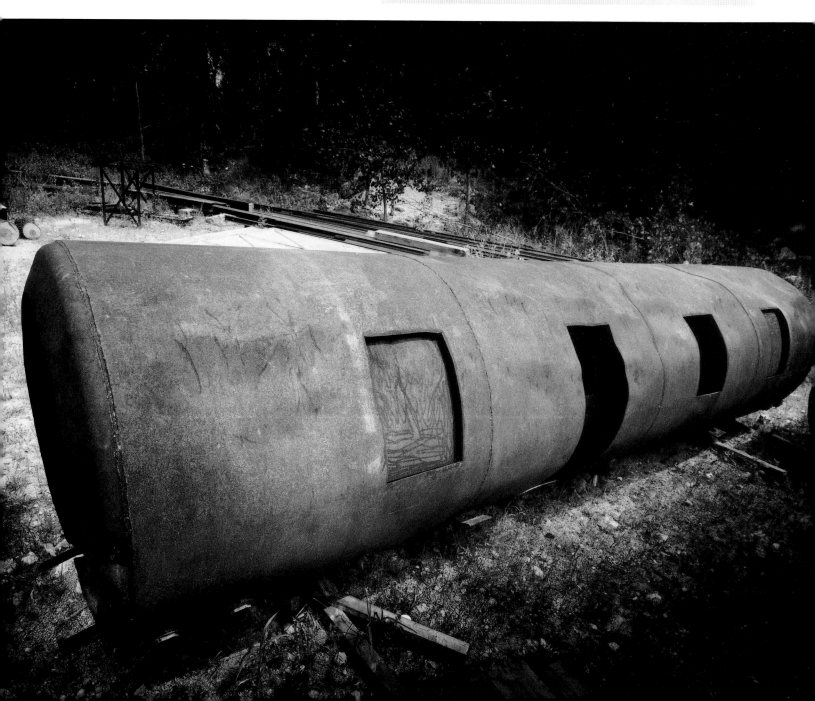

LOUISE BOU

RGEOIS

Geometry has no scale unless you give it scale. You can see it as the size of the universe, or you can see it as the size of a crawling snail. You must give geometry a size. This piece was invested with the size of the family. It is scaled to the relations of the family and the house. | The opening and the mechanics are very important, because the small one can roll in and out without interference and with great ease. They each have their place but they're completely isolated from each other. But on the other hand, to be next to each other is better than to be lost in the outside. | It relates to birth, sex, excretion—taking in and pushing out. In and out covers all our functions. In and out is a key to the piece. It's a meditation on these words, a metaphor for being in and out of trouble, in and out of fashion, in and out of line, in and out of synch, in and out of focus, in and out of bounds. | A two-some is a closed world. Two people constitute an environment. One person alone is an object. An object doesn't relate to anything unless you make it relate, it has a solitary and poor and pathetic quality. As soon as you get concerned with the other person, it becomes an environment, which involves not only you, who are contained, but also the container. | It is very important to me that people be able to go around the piece. Then they become part of the environment—although in some ways it is not an environment but the relation of two cells. | Installation is really a form between sculpture and theater, and this bothers me. What the visitor thinks and feels interests me. But I am not doing things *for* people, I'm doing things for myself. This has to be understood. I am not a teacher. I do not want to preach or convince. All I want is the right to affirmation, which is very modest. Very modest. | If the viewer is trying to find out what I want to say, they cancel themselves out of the game. The person has to be free and in touch with their emotions, with their intellects. The point is to have a reaction when they see that thing. If they say, "Hey, this bothers me, suddenly I'm breathing faster," or "I'm startled," this I do like. I don't want them to be interested in me, I want them to be interested in what I did. If it bothers them, then I'm really successful. If it doesn't bother them, I feel I don't have any communication. It makes me feel lonely, if they don't react. FROM AN INTERVIEW WITH ROBERT STORR

Opposite top: The artist's home in Easton, Connecticut, c. 1947

Opposite middle: Louise Bourgeois. Preparatory sketch for TWOSOME. 1991. Pencil on paper, 8½ x 11". *Photo: Erik Landesberg*

Opposite bottom: Louise Bourgeois. Untitled (work for *Dislocations*). 1990. Steel gas tanks. *Photo: Peter Bellamy*

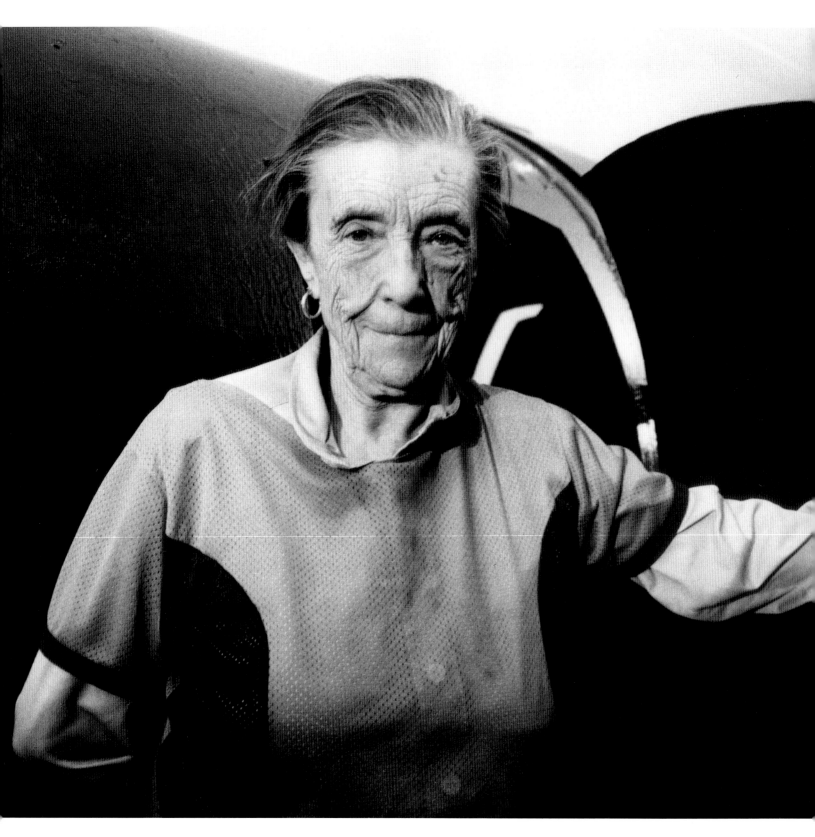

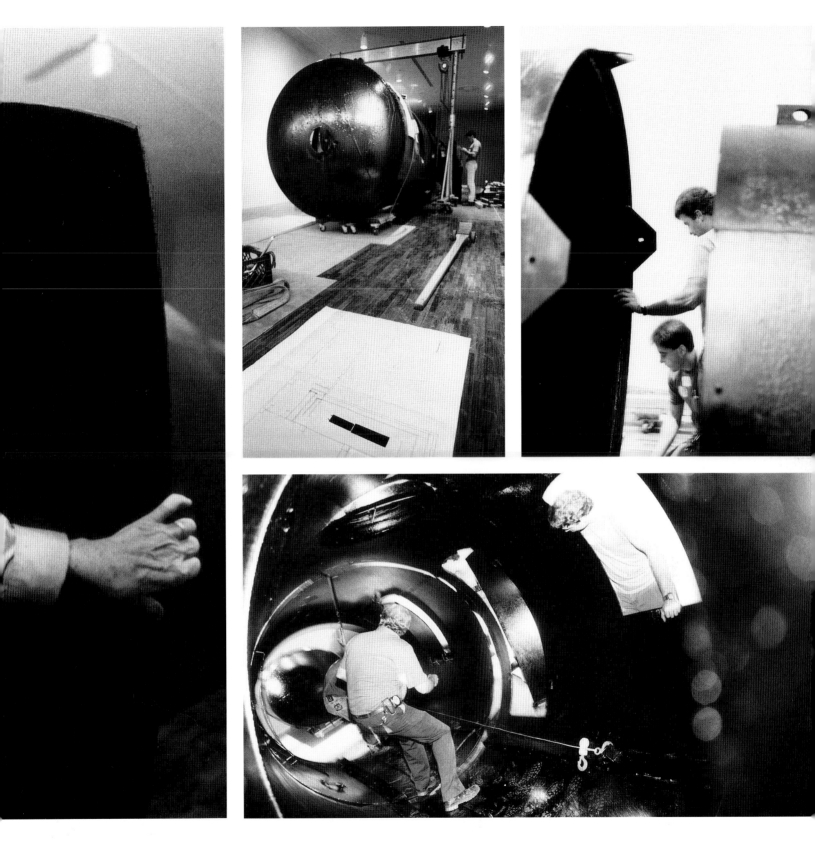

Louise Bourgeois. TWOSOME. 1991. Steel, motor, and paint; 6'3⅛" D, 40'5½" L (extended).
Courtesy Robert Miller Gallery, New York. *Photos: Peter Moore*

40

BORN
Paris, 1911
Lives in New York

SELECTED
SOLO
EXHIBITIONS

1989–91
*Louise Bourgeois:
A Retrospective Exhibition,*
Frankfurter Kunstverein
(traveling exhibition)

1989
Louise Bourgeois—Sculpture,
Robert Miller Gallery,
New York

*Louise Bourgeois: Works from the
Sixties,* DIA Art Foundation,
Bridgehampton, New York

1987–89
Louise Bourgeois,
The Taft Museum, Cincinnati
(traveling exhibition)

1987
The Louise Bourgeois Exhibition,
The Art Museum of Florida
International University, Miami

1985
Louise Bourgeois, Serpentine
Gallery, London

*Louise Bourgeois: Retrospektive 1947–
1984,* Maeght-Lelong, Paris

1982–83
Louise Bourgeois: Retrospective,
The Museum of Modern Art,
New York

1982
*Louise Bourgeois: Sculpture and
Drawings,* Robert Miller Gallery,
New York

1981
Louise Bourgeois: Femme Maison,
Renaissance Society,
University of Chicago

1980
The Iconography of Louise Bourgeois,
Max Hutchinson Gallery,
New York

1979
*Louise Bourgeois, Sculpture 1941–
1953. Plus One New Piece,* Xavier
Fourcade Gallery, New York

1978
*Triangles: New Sculpture and
Drawings 1978,* Xavier Fourcade
Gallery, New York

1974
Sculpture 1970–1974,
112 Greene Street, New York

1964
Louise Bourgeois Recent Sculpture,
Stable Gallery, New York

1953
*Louise Bourgeois:
Drawings for Sculpture and Sculpture,*
Peridot Gallery, New York

1950
Sculptures, Peridot Gallery,
New York

1949
*Late Work 1947 to 1949:
17 Standing Figures,*
Peridot Gallery, New York

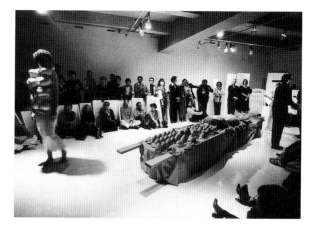

SELECTED
GROUP
EXHIBITIONS

1989
Magiciens de la Terre, Centre
Georges Pompidou, Paris

Bilderstreit, Museum Ludwig,
Cologne

1987
Biennial Exhibition,
Whitney Museum of
American Art, New York

1985
Eau de Cologne, Monika Sprüth
Gallery, Cologne

1984–85
*Third Dimension:
Sculpture of the New York School,*
Whitney Museum of
American Art, New York

Primitivism, The Museum of
Modern Art, New York

1983
Biennial Exhibition,
Whitney Museum of American
Art, New York

1973
Biennial Exhibition,
Whitney Museum of American
Art, New York

1970
*Annual Exhibition: Contemporary
American Sculpture,* Whitney
Museum of American Art,
New York

1968
Annual Exhibition: Sculpture,
Whitney Museum of
American Art, New York

1965
*Les Etats Unis: Sculpture
du XX Siècle* (organized under
the auspices of the International
Council of The Museum
of Modern Art, New York),
Musée Rodin, Paris

1963
Whitney Museum of
American Art, New York

1962
*Annual Exhibition: Sculpture
and Drawings,* Whitney Museum
of American Art, New York

1960
*Annual Exhibition:
Contemporary Sculpture and
Drawings,* Whitney Museum of
American Art, New York

Aspects de la Sculpture Americaine,
Claude Bernard Gallery, Paris

1955–57
*Annual Exhibition of Contemporary
American Sculpture, Watercolors and
Drawings,* Whitney Museum of
American Art, New York

Left to right: SOLO EXHIBITION. 1950. Peridot Gallery, New York. *Photo: Aaron Siskind*

THE DESTRUCTION OF THE FATHER. 1974. Latex, plaster, and mixed mediums, 7'9⅝" x 11'10⅝" x 8'1⅞". *Photo: Peter Moore*

CONFRONTATION, 1978, mixed mediums, and performance of A BANQUET / A FASHION SHOW OF BODY PARTS,
October 21, 1978, at the Hamilton Gallery of Contemporary Art, New York. *Photo: Peter Moore*

1953
Annual Exhibition of Contemporary American Sculpture, Watercolors and Drawings, Whitney Museum of American Art, New York

1951
Annual Exhibition of Contemporary American Sculpture, Watercolors and Drawings, Whitney Museum of American Art, New York

1946
Annual Exhibition of Contemporary American Sculpture, Watercolors and Drawings, Whitney Museum of American Art, New York

1945
The Women, Art of This Century Gallery, New York

Annual Exhibition of Contemporary American Painting, Whitney Museum of American Art, New York

SELECTED
BIBLIOGRAPHY

Bloch, Susi. "An Interview with Louise Bourgeois." *The Art Journal* (Summer 1976): 370–73.

Bourgeois, Louise. "Freud's Toys." *Artforum* (January 1990): 111–13.

Bourgeois, Louise. "A Project by Louise Bourgeois." *Artforum* (December 1982): 40–47.

Brenson, Michael. "A Sculptor Comes Into Her Own." *The New York Times*, 31 October 1982, H29.

Gardner, Paul. "The Discreet Charm of Louise Bourgeois." *Artnews* (February 1980); 80–86.

Hughes, Robert. "A Sense of Female Experience." *Time*, 22 November 1982, 116.

Kirili, Alain. "The Passion for Sculpture—A Conversation with Louise Bourgeois." *Arts* (March 1989): 68–75.

Larson, Kay. "Bourgeois at Her Best." *New York*, 1 October 1984, 60–61.

Lippard, Lucy R. "Louise Bourgeois: From the Inside Out." *Artforum* (March 1975): 26–33 (reprinted from *From the Center: Feminist Essays on Art* [New York: Dutton] 1976).

Morgan, Stuart. "Taking Cover: Louise Bourgeois interviewed by Stuart Morgan." *Artscribe* (January/February 1988): 30–34.

Pels, Marsha. "Louise Bourgeois: A Research for Gravity." *Art International* (October 1979): 46–54.

Storr, Robert. "Louise Bourgeois: Gender & Possession." *Art in America* (April 1983): 128–37.

Wallach, Amei. "A Life Transformed By Sculpture." *Newsday*, 31 October 1982: Section 2, pp. 2–3.

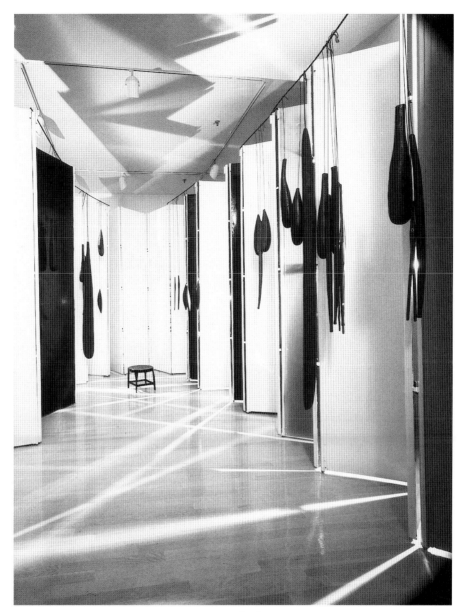

ARTICULATED LAIR. 1986. Rubber, various sizes; steel, 11' high. *Photo: Peter Bellamy*

THE OTHER VIETNAM MEMORIAL

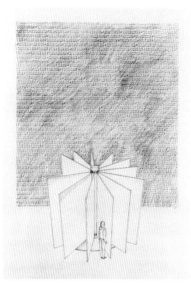

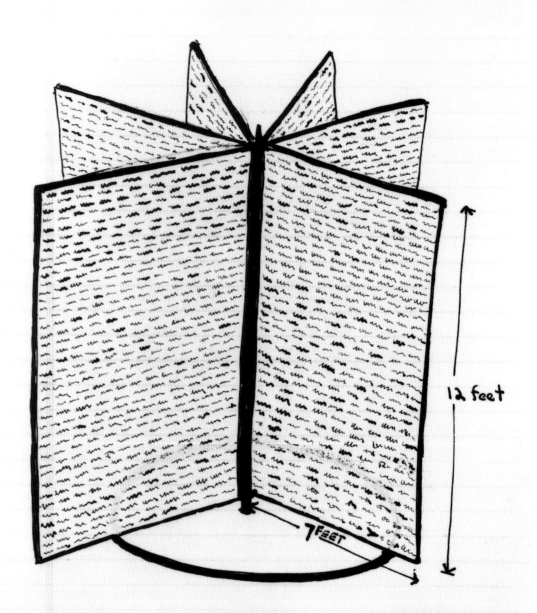

12 feet

7 FEET

A list of 3 million VIETNAMESE killed
DURING THE U.S. INVOLVEMENT IN VIETNAM
COPPER PAGES, HINGED ON CENTRAL POLE
CAN BE TURNED BY VIEWERS. Chris Burden 1991

Left: Leo Modrcin. Preparatory sketch for THE OTHER VIETNAM MEMORIAL. 1991.
Graphite, rubbing on paper, 36⅛ x 24". *Photo: Erik Landesberg.*

Right: Chris Burden. Preparatory sketch for THE OTHER VIETNAM MEMORIAL. 1991.
Ink on paper, 11 x 8½". *Photo: Erik Landesberg*

I just thought somewhere there should be a memorial to the Vietnamese that were killed in the war. So I wanted to make this book, sort of like Moses' tablet, that would be an official record of all these three million names. I would suspect that we will be lucky if we get twenty-five percent of the names; other ones would be nameless, basically faceless, bodies. They weren't even written down. Little x's, as opposed to names. There will be a lot more x's, and that says something right there. │ I don't think anyone has ever

CHRIS BURDEN

thought about the Vietnamese dead, or that there's such an imbalance. The piece is just a presentation of fact. It's information in a slightly altered form. I want the size of the sculpture, of the book, to reflect the enormity of this horror. │ The work really talks about the U.S. and the idea that you could fix everything up with might. I also think of this recent war and hearing things like "The stigma of Vietnam is now erased." I mean, no matter how good you feel about this last war, I think this piece addresses our whole consciousness in this country, which is basically "Carry a big stick and whomp 'em." │ To me it's sort of a test. If the elite audience that comes to The Museum of Modern Art gets angered by this and feels it's muckraking, then imagine what a sort of Joe Average will feel about the "other" Vietnam memorial. So the audience is definitely part of the work. It's really a litmus test: I'm curious to see how people will react. │ Just to bring the issue up is political, or I'm sure will seem that way. For me it's sort of problematic because I like the grayer zones better, where good and evil are not so clear. But in this case I don't think you can look at this list and see that there are three million names and not think, "Jesus Christ, what did we do in Vietnam?" │ The basic point is that human beings have this huge capacity for great good and great evil, and there's nothing inherently evil in anybody or inherently good. Hopefully, people will be good, but information's part of it, and the information's out there. You have to know some history, it helps you to know the right course to take. But if the evil is always suppressed and hidden, then it can keep growing like a fungus. FROM AN INTERVIEW WITH ROBERT STORR

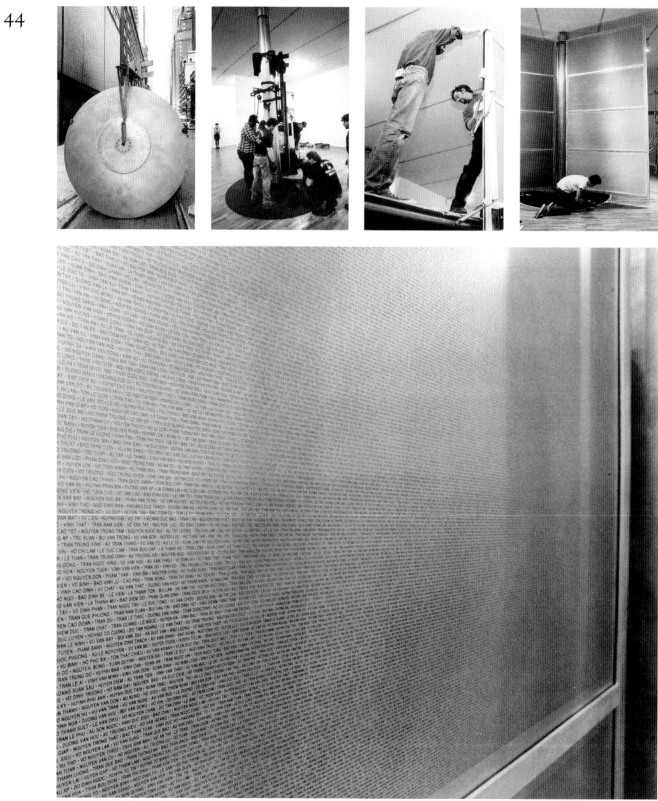

Chris Burden. THE OTHER VIETNAM MEMORIAL. 1991. Steel and etched copper, 13'8" H, 9'11" D.
Collection Lannan Foundation, Los Angeles. *Photos: Peter Moore*

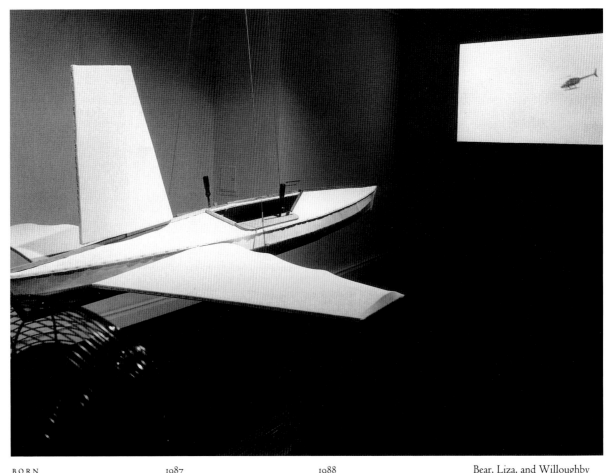

BORN
Boston, April 11, 1946
Lives in California

SELECTED
SOLO
EXHIBITIONS

1989
Kent Fine Art, New York

Josh Baer Gallery, New York

1988
Newport Harbor Art Museum,
Newport Beach, April 17–June
12. Traveled to the Institute of
Contemporary Art, Boston,
February 18–April 9, 1989;
Carnegie-Mellon University Art
Gallery, Pittsburgh, May 13–
July 9, 1989

1987
Hoffman Borman Gallery, Santa
Monica, California

1983
Ronald Feldman Fine Arts,
New York

1982
Rosamund Felsen Gallery,
Los Angeles

1980
Ronald Feldman Fine Arts,
New York

SELECTED
GROUP
EXHIBITIONS

1990
Just Pathetic, Rosamund Felsen
Gallery, Los Angeles

*New Works for the New Spaces:
Into the Nineties*, Wexner Center
for the Visual Arts, Columbus

1988
Committed to Print, The Museum
of Modern Art, New York

1981
Inaugural Exhibition, Museum of
Contemporary Art, Los Angeles

1979
The Reason for the Neutron Bomb,
Ronald Feldman Fine Arts,
New York

SELECTED
BIBLIOGRAPHY

Bear, Liza. "Chris Burden . . .
Back to You: An Interview with
Liza Bear." *Avalanche* (May–June
1974): 12.

Bear, Liza, and Willoughby
Sharp. "Chris Burden: The
Church of Human Energy."
Avalanche (Summer–Fall 1973):
54–61.

Burden, Chris. "B-Car." *Choke*
(September 1976): 23–26.

———. *Chris Burden 71–73* (Los
Angeles: Chris Burden, 1974).

———. *Chris Burden 74–77.*
(Los Angeles: Chris Burden,
1978).

———. "Chris Burden." *Flash
Art* (January–February 1977):
40–44.

———. "Garcon [*sic*]."
Art Contemporary no. 2–3 (1977):
14–15.

THE FLYING KAYAK. 1982. Canvas kayak with wings and rudder, suspended six feet above the gallery floor; four industrial fans; and 16 mm color film loop. Kayak: 9' wing span, 4'6" H x 12'6" L; fans: 70" H; wooden staircase (not in photo): 7'1" H x 31½" L x 64" W. Shown installed at Ronald Feldman Fine Arts, New York. The Museum of Modern Art, New York. Purchase. *Photo: D. James Dee*

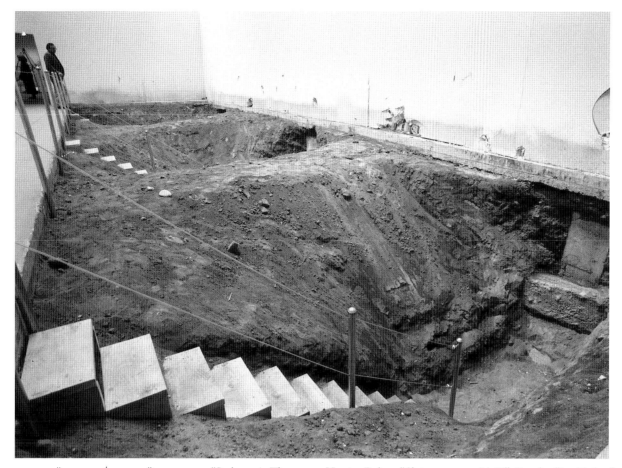

———. "100 M.P.H./100 M.P.G." *Criss Cross Double Cross* (Fall 1976): 37–38.

———. "Coals to Newcastle." *High Performance* (March 1979): 12–13.

———. "The Curse of Big Job." *High Performance* (March 1979): 2–3.

———. "Oracle." *Vision* (September 1975): 50–51.

———. "Chris Burden." *Flash Art* (June–July 1975): 39–41.

———. "Sculpture in Three Parts." *Art Com* (Summer 1975): 15–19.

Burden, Chris, and Alexis Smith. *B-Car: The Story of Chris Burden's Bicycle Car* (Choke Publications, 1977).

Burden, Chris, and Jan Butterfield. "Chris Burden: Through the Night Softly." *Arts* (March 1975): 68–72.

Cooper, Dennis. "Chris Burden: Christine Burgin Gallery." *Artforum* (March 1988): 136.

Goldberg, Roselee. "Chris Burden 71–73." *Art-Rite* (Winter 1976–77): 40.

Horvitz, Robert. "Chris Burden." *Artforum* (May 1976): 24–31.

Knight, Christopher. "The Proof of Burden Exhibit Is in Its Power." *Los Angeles Herald Examiner*, 8 May 1988, E1–E2.

———. "Artist Chris Burden Rediscovers Tradition." *Los Angeles Herald Examiner*, 22 January 1984, E5.

Larson, Kay. "Best of Burden." *New York Magazine*, 18 September 1989, 65–66.

McGill, Douglas. "Art Made of I-Beams and Concrete." *New York Times*, 3 August 1984, part 3, p. 22.

Review of Chris Burden's *Dreamy Nights*, in *Avalanche*, (December 1974): 13.

Review of Chris Burden's *Deadman*, in *Avalanche* (Winter–Spring 1973): 2.

Review of Chris Burden's *You'll never see my face in Kansas City*, in *Avalanche* (Spring 1972): 6.

Schjeldahl, Peter. "Brainy Bliss." *Seven Days*, 1 November 1989, 68.

White, Robin. "Interview: Chris Burden." *View* (January 1979): 1–20.

EXPOSING THE FOUNDATION OF THE MUSEUM. 1986. "Individuals: A Selected History of Contemporary Art," Inaugural Year Exhibit, December 1986–January 1988. Collection of The Museum of Contemporary Art, Los Angeles. *Photo: Squidds and Nunns*

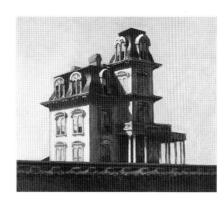

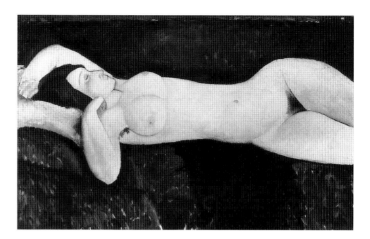

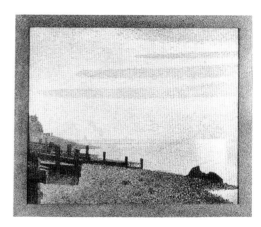

Clockwise from upper left:

Edward Hopper. HOUSE BY THE RAILROAD. 1925. Oil on canvas, 24 x 29". Given anonymously. *Photo: Kate Keller*

Amedeo Modigliani. RECLINING NUDE. c. 1919. Oil on canvas, 28½ x 45⅞". Mrs. Simon Guggenheim Fund. *Photo: Soichi Sunami*

Georges-Pierre Seurat. EVENING, HONFLEUR. 1886. Oil on canvas, 25¾ x 32". Gift of Mrs. David M. Levy. *Photo: Soichi Sunami*

Giorgio de Chirico. THE ENIGMA OF A DAY. 1914. Oil on canvas, 6'1¼" x 55". James Thrall Soby Bequest. *Photo: Kate Keller*

They sometimes put a photo in place of a missing painting, or a piece of paper that says, "This is the work of so and so and was lent to this museum from this date to that date." In French they call that a *fantôme*—a ghost; I don't know if they say that in English. │ What I did was to replace the painting with the memories of people. Just anybody that is used to passing it. I'm not only interested in people who have to look at the painting, like curators, but also in people who simply go because they follow that same path, like when you take a road to go back to your house and you cross a street again and again, because it's just there on your way. They can be somebody who cleans, the guards. │ I never have an idea about the quality of their memory. I am not surprised by what they say. It might be the smallest little details that move me the most. There is no rule.

SO

PHIE CALLE

The interest lies in the traces people leave behind, in the details of life, when you don't know who they are, but you know what kind of toothbrushes they use, or how they leave their bed undone. │ What

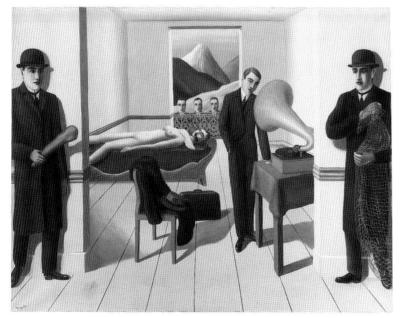

prompted me here is that I was in front of that empty spot with two nails in the wall. And that's all. I just saw that hole in the wall and two nails, and the little piece of paper that was supposed to tell you what was there—and it just came to me. There is no other way to explain it. It's just the emptiness that gave me the idea. Or the shape. Sometimes when a painting is removed there is a shape that stays there. That simply called the idea forth naturally. For me it's not natural to say why I do it and what I feel. FROM AN INTERVIEW WITH ROBERT STORR

René Magritte. THE MENACED ASSASSIN. 1926. Oil on canvas, 59¼" x 6'4⅞". Kay Sage Tanguy Fund. *Photo: Rolf Peterson*

Sophie Calle. GHOSTS. 1991. Paint, silkscreen, and color laser prints. Dimensions of the installation pieces:
HOUSE BY THE RAILROAD, 38 x 48"; RECLINING NUDE, 31 x 49"; EVENING, HONFLEUR, 31 x 38";
THE ENIGMA OF A DAY, 7'8" x 6'11"; THE MENACED ASSASSIN, 6'10" x 7'8". Collection the artist. *Photos: Peter Moore*

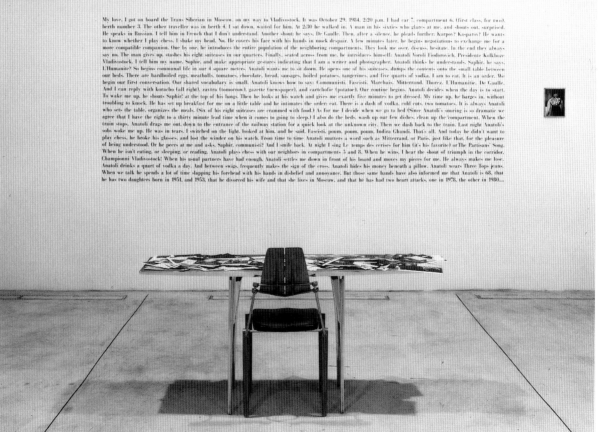

Top: AUTOBIOGRAPHICAL STORIES. 1988. Texts, black and white photographs with wooden frames, six gelatin-silver prints; photographs: each approximately 39½ x 67"; enlarged text: 19¾ x 19¾". Shown installed at the Auxiliary Gallery, Fred Hoffman Gallery, Santa Monica, July 1989. *Photo: Squidds and Nunns*

Bottom: ANATOLI. 1984. Stenciled graphite, 265 black and white and color photographs; edition #2/2; text: 54½" x 11'8", photographs: each, 7½" x 9¼". Shown installed at the Pat Hearn Gallery, New York. *Photo: Tom Warren*

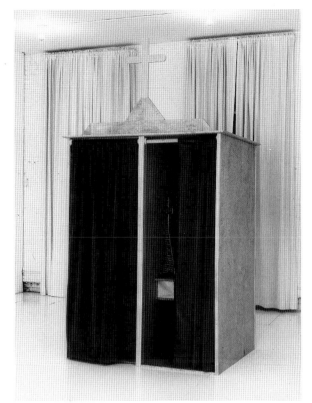

BORN
Paris, 1953
Lives in Paris

SELECTED
SOLO
EXHIBITIONS

1991
Luhrig Augustine Gallery,
New York

Pat Hearn Gallery, New York

A Suivre..., Musée d'Art
Moderne de la Ville de Paris

1990
The Institute of Contemporary
Art, Boston

Matrix Gallery, University of
California at Berkeley

Galeria La Maquina Española,
Madrid

Galerie Crousel-Robelin/
BAMA, Paris

1989
Fred Hoffman Gallery,
Santa Monica

1988
Galeria Montenegro, Madrid

1987
Centre d'Art de Flaine, Cluses

1986
Ecole Regionale des
Beaux-Arts Georges Pompidou
de Dunkerque

Centre d'Art Contemporain,
Orléans

Galerie Crousel-Hussenot, Paris

De Appel, Amsterdam

School of Fine Art, Hobart,
Tasmania

1985
Association Pour l'Art
Contemporain, Nevers

Museotrain FRAC Limousin,
Limoges

1984
Espace de rue Formi, Nîmes

1983
Galerie Chantal Crousel, Paris

1981
Canon Photo Gallery, Geneva

SELECTED
GROUP
EXHIBITIONS

1989
At Face Value, Kettles Yard
Gallery, Cambridge, England

Culture Medium, International
Center of Photography,
New York

Shifting Focus, Serpentine Gallery,
London

Nos Années 80, Fondation
Cartier, Jouy-en-Josas

Histoires de Musée, Musée d'Art
Moderne de la Ville de Paris

L'Invention d'un Art, Centre
Georges Pompidou, Paris

1988
Art & Text, First Bank Skyway
Gallery, Minneapolis

*Tendances Actuelles de la Photographie
en France*, Centre National de la
Photographie, Paris

1987
The New Who's Who, Hoffman
Borman Gallery, Santa Monica

1986
'F' Four French, Lang & O'Hara
Gallery, New York

1984
La Chambre, Centre National
de la Photographie,
Palais de Tokyo, Paris

1981
Autoportraits, Centre Georges
Pompidou, Paris

Galerie Zabriskie, Paris

1980
Une Idée en l'Air,
The Clocktower, New York;
Fashion Moda, New York

SELECTED
BIBLIOGRAPHY

Alden, Todd. "Family Plots."
Arts (February 1990): 71–74.

Baudrillard, Jean. "Please
Follow Me." Postface to *Suite
Vénitienne* by Sophie Calle, 1988.

Breslauer, Jan, and Connie
Hatch. "Sophie Calle on
Watching Big Brother." *L.A.
Weekly*, 1 September 1989, 39.

Carr, C. "Unauthorized
Access." *Village Voice*,
22 August 1989, 94.

Casadio, Mariuccia. "Sophie
Calle: Private Eye." *Interview*
(March 1991): 60.

Gerstler, Amy. "Sophie Calle.
Fred Hoffman." *Artscribe*
(January/February 1990): 85.

Irmas, Deborah. *Sophie Calle: A
Survey*. Santa Monica:
Fred Hoffman Gallery, 1989.

Knight, Christopher. "A
Cultural Self-Portrait, Warts
and All." *The Los Angeles Herald
Examiner*, 7 August 1987, 41.

Pagel, David. "Sophie Calle."
Arts (November 1989): 97.

Pincus, Robert L. "Sophie
Calle: The Prying Eye."
Art in America (October 1989):
192–97.

Raison, Bertrand. *Sophie Calle*
(Cluses, France: Centre d'Art de
Flaine, 1987).

Renard, Delphine, and
Christian Caujolle. *Anatoli*
(Dunkirk: Ecole Regionale des
Beaux-Arts Georges Pompidou
de Dunkerque, 1986).

Rochette, Anne. "The Post-
Beaubourg Generation." *Art in
America* (June 1987): 46–47.

Scarpetta, Guy. "Sophie Calle:
le jeu et la distance." *Art Press*
(February 1987): 111.

Smith, Roberta. "Young East
Villagers at Sonnabend
Gallery." *The New York Times*,
24 October 1986, C30.

Weissman, Benjamin.
"Sophie Calle — Fred Hoffman
Gallery." *Artforum* (November
1989): 161.

SUITE VÉNITIENNE. 1980–91. Confessional and audio, 9'8" x 63" x 49½".
Shown installed at the Pat Hearn Gallery, New York, 1991. *Photo: Tom Warren*

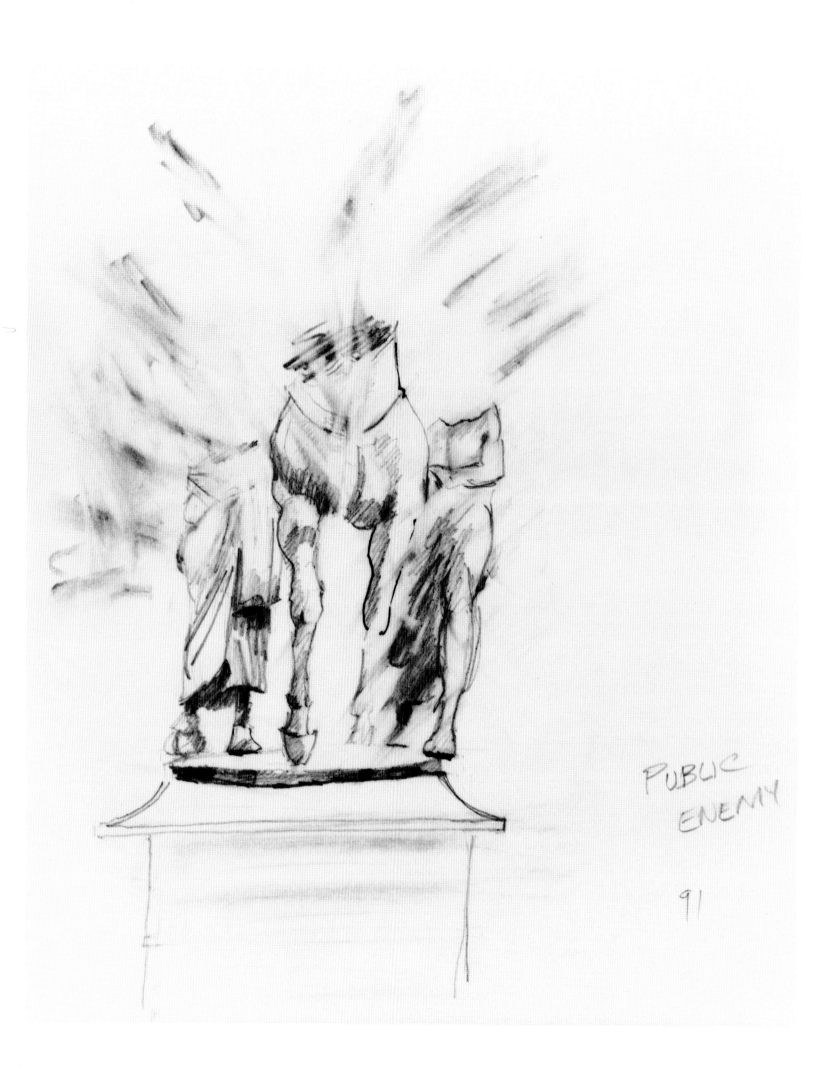

PUBLIC
ENEMY

91

I think we're pretty much numb to the visual arts in New York City. But we still have to go out and attempt it, even if you know you're failing. It's like watching basketball. There's no play that hasn't been made. So in art I'm slightly impressed once in a while, but mainly I'm trying to find a new vocabulary that I'm not used to, that frightens me and brings richness to me and this great city. | It's hard dealing with that white cube. I don't see the importance of interacting with it. To me it's like playing Carnegie Hall or Lincoln Center. I started off showing on paintboards in Jewish recreation centers because they were the only ones in Los Angeles that gave shows to black artists. I've shown around swimming pools, with art on easels, art on trees, in bars, in barbershops and cafés. I've done all that. The white walls are so difficult because everything is out of context. They don't give me any information. It's not the way my culture perceives the world. We would never build a shape like that or rooms that way. To us that's for mad people, you get put in them in the hospital.

DAVID HAMM

There's no other place that I'd seen that kind of room until I came into the art world. | I'm prepared, regardless. You have to be prepared to burst in that ray of

ONS

light when it comes and do with it whatever. I have to meet the challenge. It's a good feeling to try and outsmart myself. This challenge is incredible because the white space is not giving any information back. You have to bring everything to it. | Art is a way to keep from getting damaged by the outside world, to keep the negative energy away. Otherwise you absorb it, if you don't have a shield to let it bounce off of. Then you really go crazy. | It's like listening to Sun Ra's music. It's so beyond blackness, or whiteness. It's over and beyond the rainbow. | Cultural statements in art can damage free thought or no-thought, which is the best thought. I would love to be free enough to have no thoughts. FROM AN INTERVIEW WITH ROBERT STORR

Opposite: David Hammons. Preparatory sketch for PUBLIC ENEMY. 1991. Pencil on paper, 8½ x 11". *Photo: Erik Landesberg*

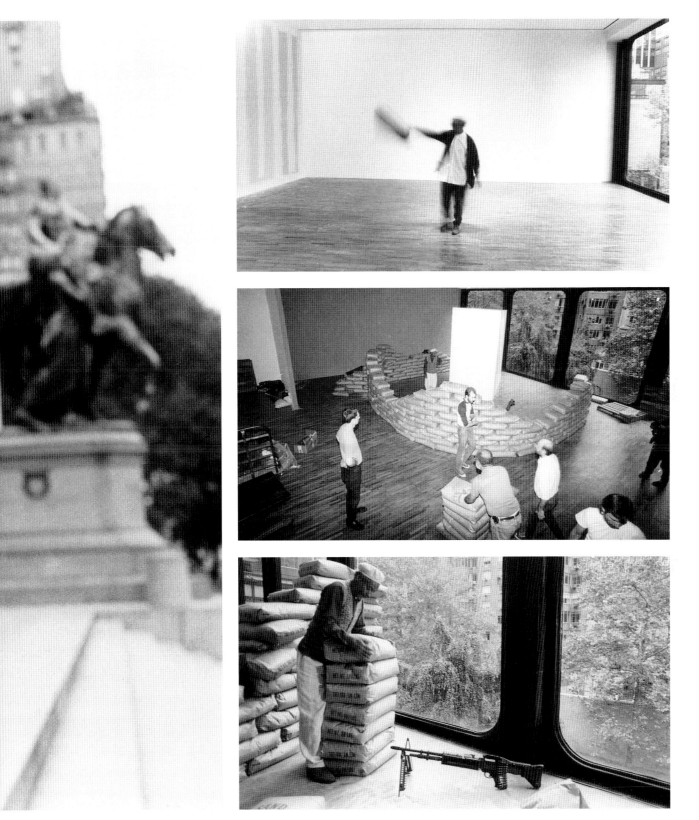

David Hammons. PUBLIC ENEMY. 1991. Photographs, sandbags, police barricades, prop weapons, confetti, balloons, leaves, and paint; dimensions of the room: 14 x 37 x 43'. Collection the artist. *Photos: Dawoud Bey*

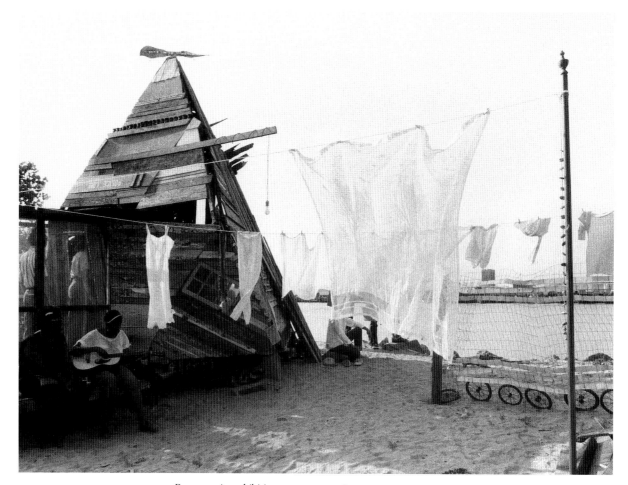

BORN
Springfield, Illinois, 1943
Lives in Harlem, New York

SELECTED SOLO EXHIBITIONS

1991
Retrospective, traveling to
Institute of Contemporary Art,
Philadelphia; San Diego
Museum of Contemporary Art

1990
Jack Tilton Gallery, New York

Retrospective exhibition.
Institute of Contemporary Art,
P.S. 1, Long Island City, New
York

1989
Exit Art, New York

1982
Higher Goals, public installation,
Harlem, New York

1980
The Window, The New
Museum of Contemporary Art,
New York

1977
Nap Tapestry: Wire and Wiry Hair,
Neighborhood Art Center,
Atlanta

1976
Dreadlock Series, Just Above
Midtown, New York

1975
Greasy Bags and Barbeque Bones, Just
Above Midtown, New York

1974
Fine Arts Gallery, Los Angeles

1971
Brockman Gallery, Los Angeles

SELECTED GROUP EXHIBITIONS

1990
The Decade Show, Studio Museum /
New Museum/MoCHA,
New York

Just Pathetic, Rosamund Felsen
Gallery, Los Angeles

Rewriting History, Kettles Yard,
Cambridge, England

Black USA, Museum
Overholland, Amsterdam

1989
Committed to Print, The Museum
of Modern Art, New York

Awards in the Visual Arts 8, High
Museum of Art, Atlanta

DELTA SPIRIT HOUSE. 1983. Mixed mediums.
Shown installed at ART ON THE BEACH, Battery Park, New York. *Photo: Dawoud Bey*

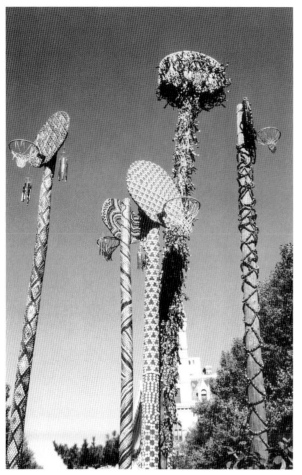

1988
Art as a Verb, Maryland Institute College of Art, Baltimore

1986
Higher Goals, Public Art Fund, Cadman Plaza, New York

1983
Art on the Beach, Battery Park, New York

Message to the Public, Spectacolor Billboard, New York

1982
Higher Goals, public installation, Harlem, New York

1980
Betty Parsons Gallery, New York

Franklin Furnace, New York

Times Square Show, New York

1972
Los Angeles County Museum of Art

1970
La Jolla Museum of Art

Oakland Museum, California

BIBLIOGRAPHY

Berger, Maurice. Interview with David Hammons, in "Issues & Commentary II. Speaking Out: Some Distance to Go . . ." *Art in America* (September 1990): 80–81.

Hess, Elizabeth. "Getting His Due." *The Village Voice*, 1 January 1991, 81.

Jones, Kellie. "David Hammons." *Real Life Magazine* (Autumn 1986): 2–9.

Kimmelman, Michael. "Giving Voice to the Ephemera of the Urban World." *The New York Times*, 19 May 1989, C33.

Kimmelman, Michael. "Turning the Familiar into the Extraordinary." *The New York Times*, 28 December 1990, C24.

Larson, Kay. "Dirt Rich." *New York Magazine*, 14 January 1991, 68.

Reid, Calvin. "Chasing the Blue Train." *Art in America* (September 1989): 196–97.

Wallach, Amei. "Pick-up Games." *New York Newsday*, 23 December 1990, part II, 3, 22.

Left: HIGHER GOALS. 1982.
Poles, basketball hoops, and bottle caps; poles, 40'. Shown installed in Brooklyn, New York, 1986. *Photo: Dawoud Bey*

Right: WHO'S ICE IS COLDER? 1990.
Flags, oil drums, and ice. Shown installed at the Jack Tilton Gallery, New York, 1990. *Photo: Ellen Page Wilson*

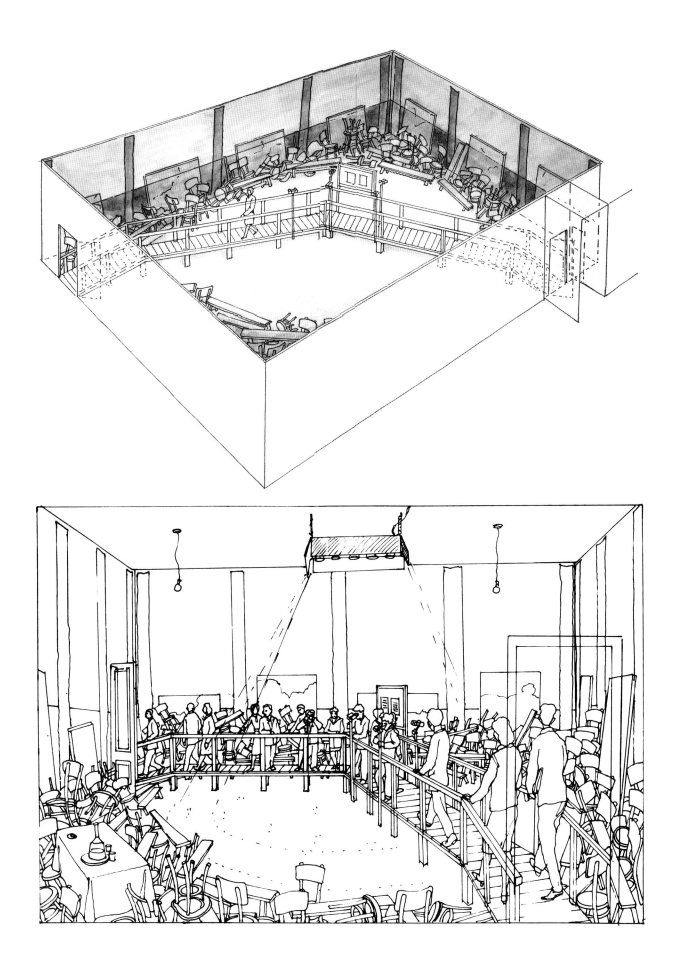

A rather ambitious attempt to establish the correlation between art and "mysticism" is embedded in
the installation. Long ago, in icons and the Gothic style, for example, art was understood as
serving a high, religious-mystical origin, and the separation of the two appeared to be simply impos-
sible. In modern times, the artistic work became autonomous. The painting, and then the artist
himself, and finally his profession itself, became his personal affair. The connection between mysti-
cism and art has become highly problematic. In the art of the Late Renaissance, the former is still
preserved, both in the subject matter and in a particular "high" order or style. But subsequently, with
the change in the subjects depicted, it's as though mysticism disappears altogether from painting.
(I am speaking here not about individual artists, but about the general state of affairs.) │ But back
to the subject at hand. The subject of the installation *The Bridge* is rather simple. In the room where
the viewer finds himself, an exhibit of paintings should have taken place, but as a result of the appear-
ance of something mysterious—mystical—it cannot take place. The paintings, freeing up the space
for the purpose, wind up being squeezed to the walls by chairs, benches, and the table, turning into
common objects much like the furniture that obscures them. Art (the "paintings," of course, repre-
sent "art") must move aside, to the edge, to the corners in the darkness, yielding to the mysterious,
"mystical" center, which is brightly illuminated. That's the story. │ But then a new genre of art
appears onstage, like the "installation" (if, of course, you can consider it to be art, and this is still a
question), giving everything a differ-
ent angle. Installation, by its very I L Y A K A
nature, may unite—*on equal terms*, with-
out recognition of supremacy—not only various forms of culture (paintings, objects, texts), but in

B A K O V general anything at all, and most of all phe-
 nomena and concepts that are extraordinarily
 far from one another. Here, politics may be com-
bined with the kitchen, objects of everyday use with scientific research, garbage with sentimental effu-
sions. . . . The installation as a genre is probably a way to give new correlations between old and familiar
things. By entering an installation, these correlations, these various phenomena, reveal their dependence,
their "separateness," but they may reveal as well their profound connection with each other, which
was perhaps lost long ago, which they at some time had, and which they always needed. And particular-
ly important is the restoration of that whole that had fallen into its parts, and that I spoke of at the
beginning of this note. EXCERPT FROM THE ARTIST'S NOTE, "THE CONCEPT BEHIND THE INSTALLATION *THE BRIDGE*"

Opposite top: Ilya Kabakov. Preparatory sketch for THE BRIDGE. 1991. Marker and color wash on paper, 11¾ x 15½". *Photo: Erik Landesberg*
Opposite bottom: Ilya Kabakov. Preparatory sketch for THE BRIDGE. 1991. Marker on paper, 11¾ x 16½". *Photo: Erik Landesberg*

Ilya Kabakov. THE BRIDGE. 1991. Wood, furniture, found and made objects, fabric, light fixtures, light bulbs, and paintings; dimensions of the room: 13 x 53 x 36'. Courtesy of Ilya Kabakov; Ronald Feldman Fine Arts, New York; Dina Vierny, Paris; Private collection, Bern. *Photos: Dawoud Bey*

64

BORN
Dnepropetrovsk, Ukraine, 1933
Lives in Moscow

**SELECTED
SOLO
EXHIBITIONS**

1990
Four Cities Project, Orchard
Gallery, Derry, Ireland,

Seven Exhibitions of a Painting,
Kasseler Kunstverein, Kassel

*The Rope of Life & Other
Installations*, Fred Hoffman
Gallery, Santa Monica

*He Lost His Mind, Undressed, Ran
Away Naked*, Ronald Feldman
Fine Arts, New York

1989
Que sont ces petits hommes?
Galerie de France, Paris
(traveling exhibition).
Traveled as *Who Are These Little
Men?* to the Institute of
Contemporary Art,
Philadelphia

*Exhibition of a Book
(Ausstellung Eines Buches)*,
Daadgalerie, Berlin

White Covers Everything but Itself,
De Appel, Amsterdam

Communal Apartment,
Kunsthalle, Zürich

1988
10 Characters, Ronald Feldman
Fine Arts, New York (traveling
exhibition). Traveled as
*The Untalented Artist and Other
Characters* to ICA, London

Before Supper, Kunstverein, Graz

1985
Kabakov: Paintings and Drawings,
Dina Vierny Gallery, Paris

Am Rande (Along the Margins),
Kunsthalle, Bern

**SELECTED
GROUP
EXHIBITIONS**

1991
Soviet Art Around 1990,
Kunsthalle, Düsseldorf
(traveling exhibition)

1990
In the U.S.S.R. and Beyond,
Stedelijk Museum, Amsterdam

*Between Spring and Summer:
Soviet Conceptual Art in the Era of
Late Communism*, Tacoma Art
Museum (traveling exhibition)

*Adaptation & Negation of Socialist
Realism*, Aldrich Museum of
Contemporary Art, Ridgefield,
Connecticut

Sydney Biennale 1990

1989
The Green Show, Exit Art, New
York (traveling exhibition)

The Beautiful '60's in Moscow, The
Genia Schreiber University
Art Gallery, Tel Aviv University

Magiciens de la Terre,
Musée National d'Art
Moderne, Centre Georges
Pompidou, Paris

1988
Bonn Kunstverein

*Ich Lebe, Ich Sehe: Künstler der
Achtziger Jahre in Moskau*,
Kunstmuseum, Bern

Venice Biennale

1987
*Gegenwartskunst aus der Sowjetunion:
Ilya Kabakov und Iwan Tschuikow*,
Museum für Gegenwartskunst,
Basel

1986
Kunstverein, Düsseldorf

Centre National des Arts
Plastiques, Paris

Exhibit of Paintings, 28 Malaja
Gruzinskaja, Moscow

Photographs and Paintings,
Center for Technical Aesthetics,
Moscow

One-Evening Exhibition
at the Soviet Artists' Union,
Artists' Club, Kuznetskij Most,
Moscow

Artists' Club, Zholtovskij
Street, Moscow

1981
*Twenty-Five Years of Soviet
Unofficial Art 1956–1981*, C.A.S.E.
Museum of Soviet Unofficial
Art, Jersey City

Russian New Wave,
Contemporary Russian Art
Center of America, New York

1979
*Twenty Years of Independent Art
from the Soviet Union*, Bochum
Museum

The Square's Fourth Dimension,
Mart Gallery, Rockenberg

1978
Russian Nonconformist Painting,
Saarland Museum, Saarbrucken

New Soviet Art, Palazzo Reale,
Turin

1977
New Art from the Soviet Union,
The Herbert F. Johnson
Museum of Art, Cornell
University, Ithaca, New York

*New Soviet Art, An Unofficial
Perspective*, Venice Biennale

1976
Contemporary Russian Painting,
Palace of Congress, Paris

1975
The Russian (Glezer Collection),
Artists' Union, Vienna

1974
*Progressive Tendencies in Moscow
(1957–1970)*, Bochum Museum

1973
Russian Avant-garde: Moscow—73,
Dina Vierny Gallery, Paris

1970
*Today's Russian Avant-garde in
Moscow*, Gmurzynska Gallery,
Cologne

New Tendencies in Moscow,
Fine Arts Museum, Lugano

1969
Moscow's New School, Interior
Gallery, Frankfurt-am-Main

Left: HE LOST HIS MIND, UNDRESSED, RAN AWAY NAKED. Installation I, MY MOTHER'S LIFE II. 1990.
Seventy framed pages of black and white photographs with texts, mounted on decorative paper, each 31 x 23" (framed).
Shown installed at Ronald Feldman Fine Arts, New York, January 6–February 3, 1990. *Photo: D. James Dee*

Right: HE LOST HIS MIND, UNDRESSED, RAN AWAY NAKED. Installation III. 1983–90. Five Socialist Realist murals
(acrylic on paper) and eight enamel paintings on masonite. Shown installed at Ronald Feldman Fine Arts,
New York, January 6–February 3, 1990. *Photo: D. James Dee*

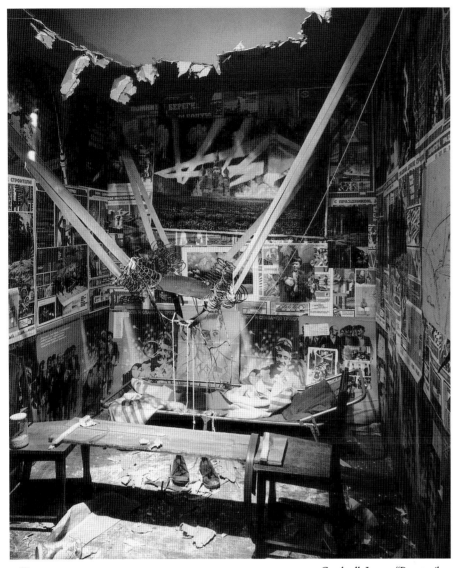

1968
Exhibition with E. Bulatov,
The Blue Bird Café, Moscow

1967
Young Moscow Artists, The Renzo
Botti Art Group, Cremona

1966
Exhibition of Sixteen Moscow Artists,
Sopot-Poznan, Poland

1965
Contemporary Alternatives/2,
Castello Spagnolo, L'Aquila,
Italy

SELECTED
BIBLIOGRAPHY

Cary, Katrina F.C. "Ilya
Kabakov: Profile of a Soviet
Unofficial Artist." *Art & Auction*
(February 1987): 86–87.

Cembalest, Robin. "The Man
Who Flew Into Space." *Artnews*
(May 1990): 176–81.

Gambrell, Jamey. "Perestroika
Shock." *Art in America* (February
1989): 124–34, 179.

Groys, Boris. "Ilya Kabakov."
A-Ja (1980): 17–23.

———. "The Zero Solution."
Manuscript, 1982.

Huttel, M. "The Mathematical
Gorsky." Manuscript, 1982.

Heartney, Eleanor. "Nowhere
to Fly." *Art in America* (March
1990): 176–77.

Ilya Kabakov: Ten Characters,
Exhibition catalogue (London:
ICA, in association with Ronald
Feldman Fine Arts, Inc., New
York, 1989).

Jolles, Claudia, and Viktor
Misiano. "Eric Bulatov and Ilya
Kabakov." *Flash Art*
(November–December 1987):
81–83.

Kabakov, Ilya. "La Pelle."
*Les Cahiers du Musée national d'art
moderne,* Centre Georges
Pompidou, Paris #26 (Winter
1988): 92–110.

Kabakov, Ilya. "Discussion of
the Three Layers." *A-Ja* (1984):
30–31.

Kabakov, Ilya. "The Kitchen
Series." *A-Ja* (1984): 26–27.

Kimmelman, Michael. "Soviet
Artist as a Storyteller of Not-
Always-Pretty Tales." *The New
York Times,* 19 January 1990, C26.

Kuzminsky, Konstantin K. *Art of
Russia and the West,* no. 1 (March
1989): 80–91.

Lloyd, Jill. "An Interview with
Ilya Kabakov: The 'Untalented
Artist'—A Schizophrenic Way
of Life." *Art International*
(Autumn 1989): 70–73.

Morgan, Stuart. "Kabakov's
Albums." *Artscribe* (May 1989):
57–59.

Salisbury, Stephan. "Painting a
New Day in Soviet Art."
The Philadelphia Inquirer,
29 December 1989, D1, D6.

Tupitsyn, Margarita. "Ilya
Kabakov." *Flash Art* (February–
March, 1986): 67–69.

Tupitsyn, Victor. "Ilya
Kabakov." *Flash Art*
(March/April 1990): 147.

THE MAN WHO FLEW INTO SPACE FROM HIS APARTMENT. 1981–88. From 10 CHARACTERS. 1988. Six poster panels with
collage, furniture, clothing, catapult, household objects, wooden plank, scroll-type painting, two pages of Soviet paper, diorama; dimensions
of the room: 8' x 7'11" x 12'3". Shown installed at Ronald Feldman Fine Arts, New York, April 30–June 11, 1988. *Photo: D. James Dee*

Left: Juliet Myers. Videotape still of singer Rinde Eckert, for Bruce Nauman, ANTHRO/SOCIO. 1991. *Photo: Juliet Myers*

Top right: Bruce Nauman. Preparatory sketch for ANTHRO/SOCIO. 1991. Pencil on paper, 18¾ x 21½". *Photo: Erik Landesberg*

Bottom right: Bruce Nauman. Lyrics to ANTHRO/SOCIO. 1991. Pen on paper, 13 x 8½". *Photo: Erik Landesberg*

I think I'm interested in a certain amount of disorientation, not in controlling the movement of viewers. │ It's a pretty aggressive piece, and the aggression comes from these three different places and keeps shifting, which makes it hard to focus. It's not easy to decide where to put your attention; seeing things out of the corner of your eye; knowing something is going on behind you. I like those ideas. I like the size of the room, it gives me a chance to make some big images without having them crowd each other. │ The equipment begins to break up the space a little bit. There's stuff projected which you can walk around or walk through, and because I have different sets of imagery I can move around—things will come at you from different places, at different times. │ It must come out of the core of why I do anything. There never seems to be an answer, and that's what keeps me interested. I don't think you can pick any one piece and figure out what the motivation was. Maybe when you look at a lot of work you have a stronger feeling for what makes it work. In a sense, maybe, it's all different ways of investigating . . . frustration. │ There's no way to avoid connections, but the most interesting ones to me are the ones where there appear to be connections from a long time ago. It's clear that there was work that I didn't totally understand when I made it and that has implications that are suddenly useful to me again. These things are sort of circular, because of what you didn't know before. It occurs in this piece. I was working with *FEED ME*, an image that I'd worked with a couple of years ago. Although that had a very powerful emotional root at the time, it has another at this time. It still has resonance. │ With this project, the phrases I wanted to use were "FEED ME, EAT ME" and "HELP ME, HURT ME," but it didn't sound so good coming out of my mouth. The complexity of the information, of the material, demanded more clarity and precision than I was able to give it myself, so I used Rinde Eckert, who is a performance artist and a classically trained opera singer. It's pretty intense. I ended up having him sing, "FEED ME/EAT ME/ANTHROPOLOGY" and "HELP ME/HURT ME/SOCIOLOGY." FROM AN INTERVIEW WITH ROBERT STORR

BRUCE NAUMAN

68

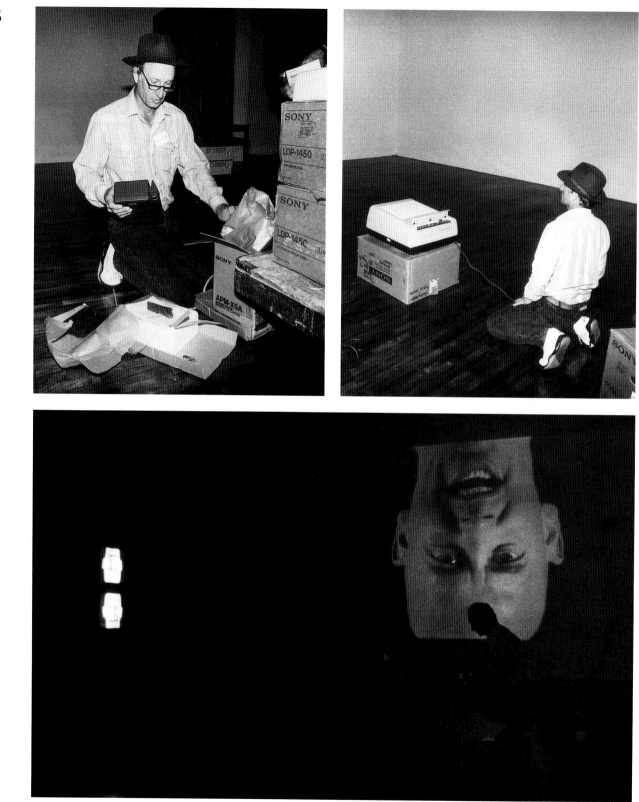

Bruce Nauman. ANTHRO/SOCIO. 1991. Video installation, disk players, monitors, projectors; dimensions of the room: 13 x 59 x 52'.
Courtesy of Leo Castelli, New York, and Sperone Westwater, New York. *Photos: Dawoud Bey*

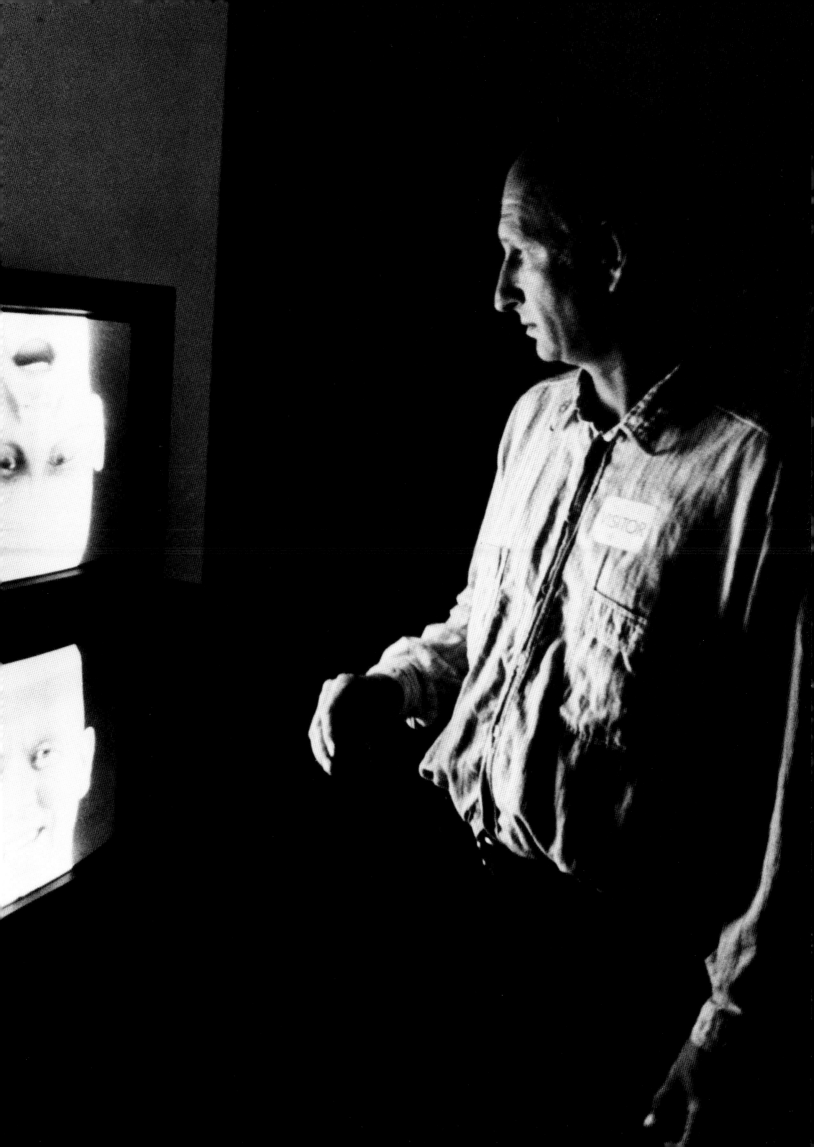

70

BORN
Fort Wayne, Indiana, 1941
Lives in New Mexico

SELECTED
SOLO
EXHIBITIONS

1989
Castelli Graphics, New York

Lorence-Monk Gallery,
New York

Donald Young Gallery, Chicago

Earl McGrath Gallery,
Los Angeles

1988
University of New Mexico,
Albuquerque (permanent
installation)

University of California,
San Diego

1986–88
Museum für Gegenwartskunst,
Basel

Kunsthalle, Tubingen

Städtisches Kunstmuseum,
Bonn

Museum Boymans–van
Beuningen, Rotterdam

Kunstraum, Munich

Badischer Kunstverein,
Karlsruhe

Hamburger Kunsthalle

The New Museum of
Contemporary Art, New York

Contemporary Arts Museum,
Houston

The Museum of Contemporary
Art, Los Angeles

University Art Museum,
Berkeley

1986–87
Kunsthalle, Basel

ARC, Musée d'Art Moderne de
la Ville de Paris

Whitechapel Art Gallery,
London

1982–83
The Baltimore Museum of Art

1976
Sonnabend Gallery, New York

Sperone Westwater Fischer,
New York

1975
Leo Castelli, New York

1974
Wide White Space, Antwerp

1973
University of California, Irvine

Leo Castelli, New York

1972–73
*Bruce Nauman: Works from
1965–1972* (traveling exhibition):
Los Angeles County Museum
of Art; Whitney Museum of
American Art, New York;
Kunsthalle, Bern; Städtische
Kunstalle, Düsseldorf; Stedelijk
van Abbemuseum, Eindhoven;
Palazzo Reale, Turin;
Contemporary Arts Museum,
Houston; San Francisco
Museum of Modern Art

1971
Ileana Sonnabend, Paris

Leo Castelli, New York

1968
Leo Castelli Gallery, New York

Konrad Fischer, Düsseldorf

1966
Nicholas Wilder Gallery,
Los Angeles

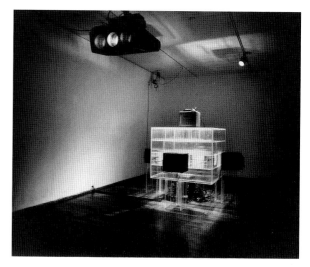

SELECTED
GROUP
EXHIBITIONS

1977
Documenta 6, Kassel

1976
Rooms P.S. 1, Institute for Art
and Urban Resources, Long
Island City, New York

1975
Drawing Now, The Museum of
Modern Art, New York;
traveled to Kunsthalle, Zürich;
Städtisches Kunsthalle, Baden-
Baden; Albertina Museum,
Vienna; Sonia Henie-Neils
Foundation, Oslo

1971
Rooms P.S. 1, Institute for Art
and Urban Resources, Long
Island City, New York

1969
When Attitude Becomes Form,
Kunsthalle, Bern; traveled to
Museum Haus Lange, Krefeld;
Institute of Contemporary Art,
London

Anti-Illusion: Materials/Procedures,
Whitney Museum of American
Art, New York

1968
9 at Leo Castelli, Leo Castelli
Warehouse, New York

1966
Eccentric Abstraction,
Fischbach Gallery, New York

BIBLIOGRAPHY

Butterfield, Jan. "Bruce
Nauman, the Center of
Yourself." *Arts Magazine*
(February 1975): 53–55.

Nauman, Bruce. "Notes and
Projects." *Artforum* (December
1970): 44.

Pincus-Witten, Robert. "Bruce
Nauman: Another Kind of
Reasoning." *Artforum* (February
1971): 30–37.

Schjeldahl, Peter. "Only
Connect," *The Village Voice*,
20–26 January 1982, 72.

Sharp, Willoughby. "Nauman
Interview." *Arts Magazine* (March
1970): 22–27.

———. "Bruce Nauman."
Avalanche (Winter 1971): 23–25.

Smith, Bob. "Interview with
Bruce Nauman." *Journal* (Spring
1982): 35–38.

Tucker, Marcia.
"PheNAUMANology,"
Artforum (December 1970):
38–44.

Left: ROOM WITH MY SOUL LEFT OUT/ROOM THAT DOES NOT CARE. 1984. Celotex, 34' x 48' x 30'6".
Shown installed at Leo Castelli, New York, 1984. *Photo: Dorothy Zeidman*

Right: RATS AND BATS (LEARNED HELPLESSNESS IN RATS) II (view 2). 1988. Three ¾" videotapes, six television monitors,
one projector, and one live camera. Shown installed at the Leo Castelli Gallery, New York, 1988. *Photo: Dorothy Zeidman*

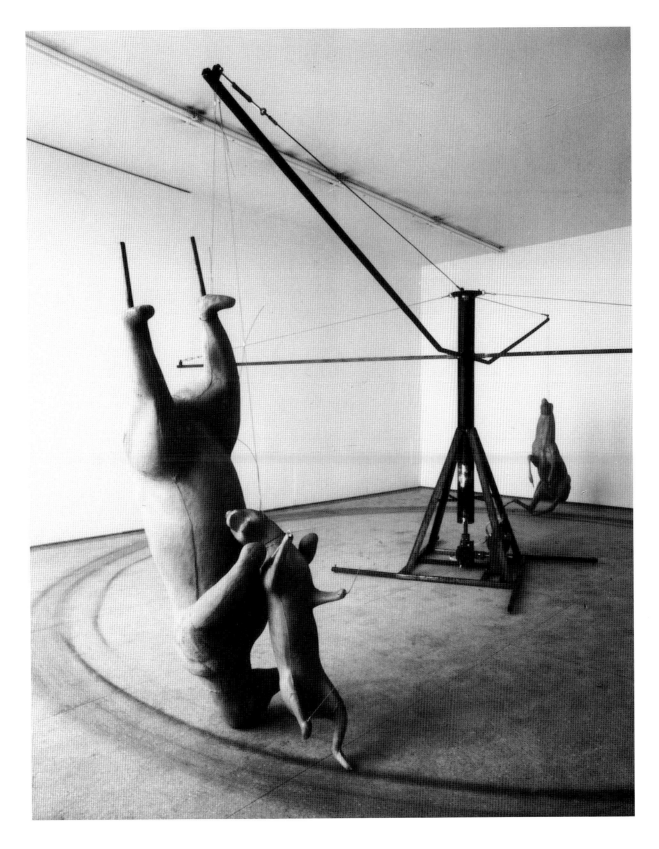

CAROUSEL. 1988. Steel and cast aluminum, 17'9" in diameter.
Shown installed at Konrad Fischer, Düsseldorf, 1988. Collection Haags Gemeentemuseum. *Photo: Dorothea Fischer*

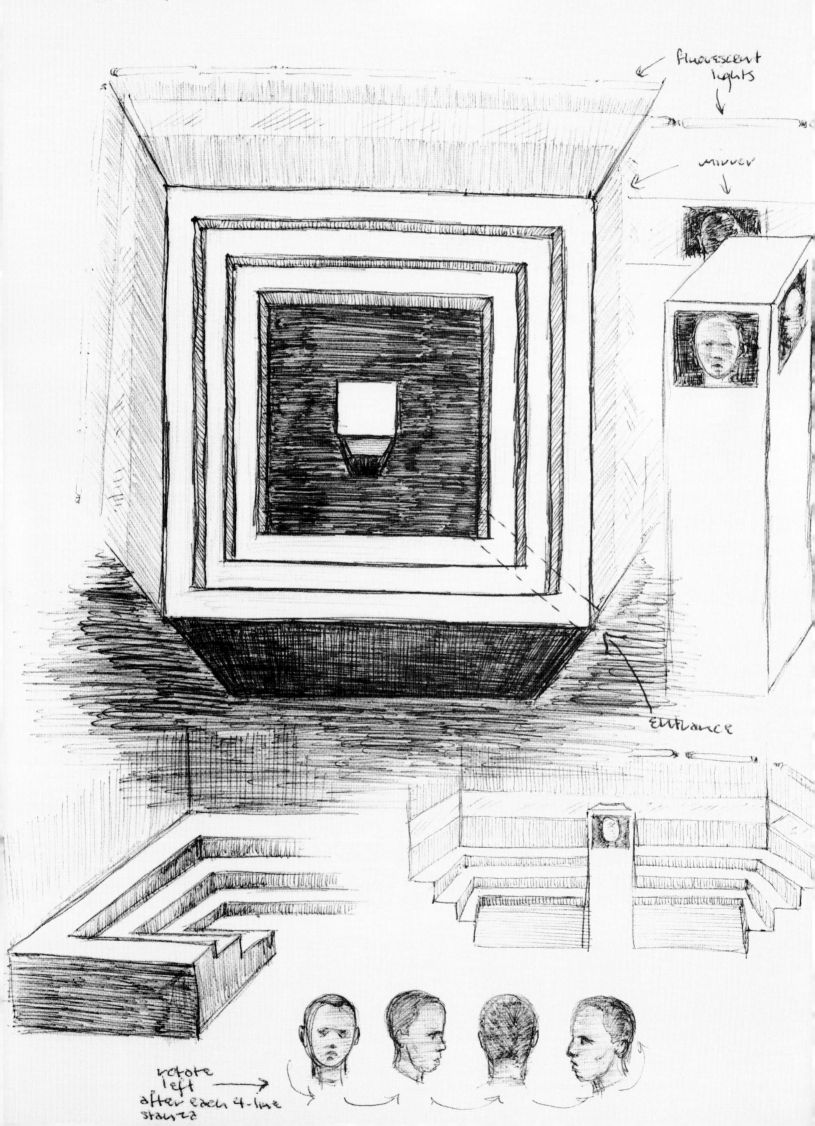

What It's Like, What It Is #3

fluorescent lights

mirror

Entrance

rotate left → after each 4-line stanza

I would like people to sit in the bleachers and think of where they are sitting as an amphitheater of the sort that one would sit in to watch Christians being devoured by the lions and also to watch football games and other sports, but also to catch the reference that they are in some sense sitting on sculpture of the late 1960s. | Western culture is intrinsically a colonizing culture. That's what it means to commit oneself to the notion of this culture's universality. So Western culture is my culture. I have very strong reservations about attempts to carve up the cultural and artistic terrain as if ethnic groups occupied discrete parts of it. I think it belongs to all of us. The underrated part is the extent to which we all contribute to it. It's not just a white male preserve. | My own training and sensibility as an artist are very strongly influenced by Minimalist and conceptual principles. This piece is an attempt to bring forward not only some aspects of my own formalist sensibilities that people keep on denying exist, but also to integrate those with concerns of race and racial identity, stereotyping, and so forth. Minimalist sculpture and ways of thinking aspired to the highest kind of universality and the most Platonic of forms. At the same time, it represented an ideological stance, in that all ideational references are intended to be absent. Those are the two sides of it I find very interesting, that Minimalism's conception of universality is exclusive rather than inclusive. One of the obstacles to inclusive universality is thinking about black people as nonpersons or as inferior or subhuman or invisible or childish or dirty. Part of the aspiration to inclusive universality, which I am totally enthusiastic about, is the naming of those impediments and the attempt to transcend them. The naming of them is, of course, an extremely unpleasant and painful matter for those who are maimed by those slurs and also for those who recognize those slurs as expressions of their own deep feelings. That's what it's all about, for me: the relation between universal categories that really do apply universally and stereotypes that purport to apply universally, but in fact represent exclusionary limitations of vision or perception or conceptualization. | I find it discouraging when someone says of my work, "The message is obvious, she's against racism." I think that expresses an unwillingness to pursue the implications of the issues and strategies I explore in the work—it's like shutting down at square one. I try for ultimate clarity, with multiple reverberations and multiple implications at the same time. I try for simplicity, not oversimplification. I don't want to make any prescriptions about what people should do. I just want to penetrate the layers of illusion and self-deception as far as possible and do it cleanly without losing any of the mind-bending complexity of the issues. FROM AN INTERVIEW WITH ROBERT STORR

A DRIAN PIPER

Opposite: Adrian Piper. Preparatory sketch for WHAT IT'S LIKE, WHAT IT IS, #3. 1991. Pen on paper, 11 x 8½". *Photo: Erik Landesberg*

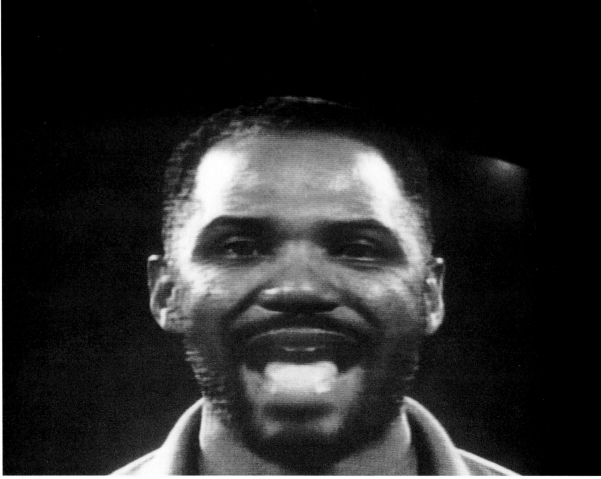

Adrian Piper. WHAT IT'S LIKE, WHAT IT IS, #3. 1991. Video installation, two audio tracks, fluorescent lighting, mirrors, and stepped construction; dimensions of the room: 14 x 31 x 31'. Adrian Piper/Courtesy John Weber Gallery, New York. *Photos: Peter Moore*

Actor: John L. Moore III

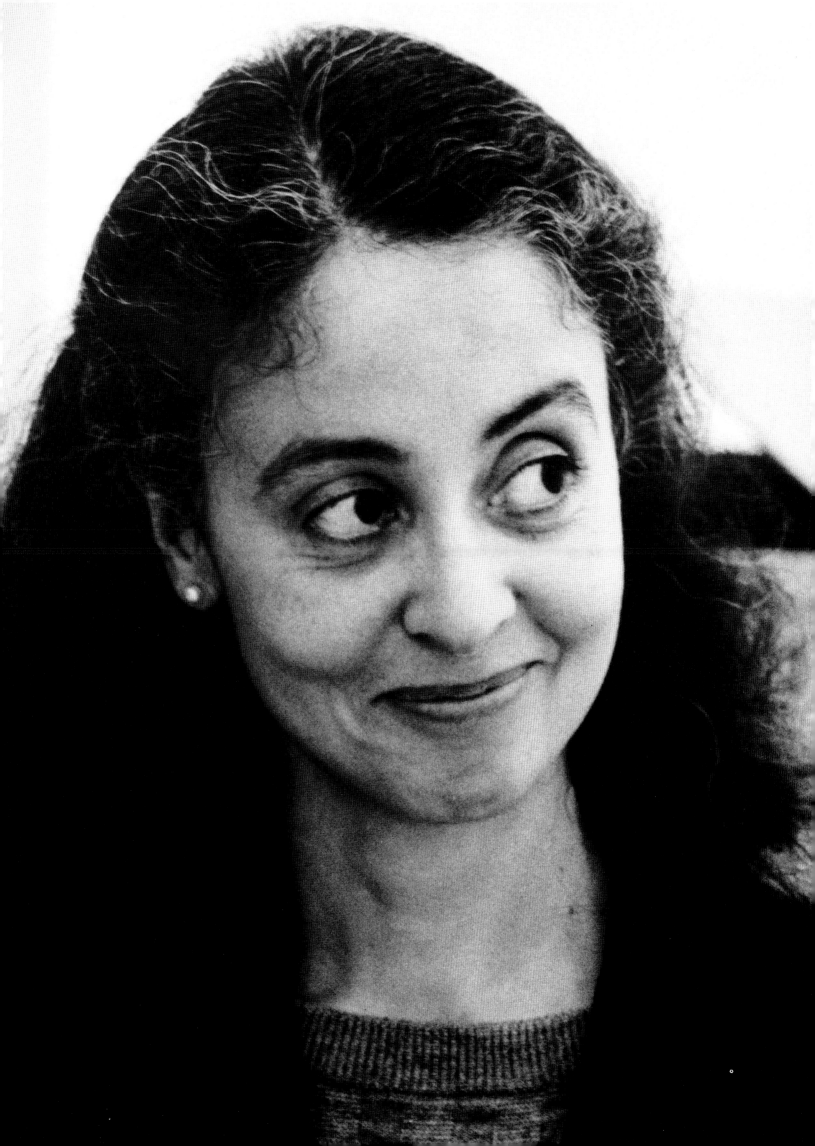

76

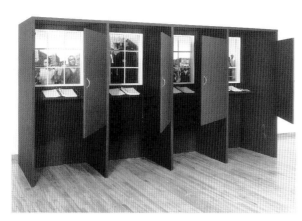

BORN
New York City, 1948
Lives in Massachusetts

EDUCATION
School of Visual Arts,
New York: A.A. (Fine Arts)
Harvard University, Cambridge:
Ph.D. (Philosophy)

**SELECTED
SOLO
EXHIBITIONS**

1991
What It's Like, What It Is, #1,
Washington Project for the
Arts, Washington, D.C.

What It's Like, What It Is, #2,
Directions Gallery, Hirshhorn
Museum and Sculpture Garden,
Washington, D.C.

*Space, Time and Reference
1967–1970,* John Weber Gallery,
New York

1990
ARTWORKS: Adrian Piper,
Williams College Museum of
Art, Williamstown

Why Guess? University of Rhode
Island Art Gallery, Kingston

Pretend, John Weber Gallery,
New York

Why Guess?, Exit Art, New York

Out of the Corner, Film and Video
Gallery, Whitney Museum of
American Art, New York

1989
Cornered, John Weber Gallery,
New York

Merge, Messages to the Public,
Times Square, New York,
Public Art Fund

Adrian Piper, Matrix Gallery,
University Art Museum,
Berkeley

1987
Adrian Piper: Reflections 1967–1987
(retrospective), The Alternative
Museum, New York. Traveled
to Nexus Contemporary Art
Center, Atlanta; Goldie Paley
Gallery, Moore College of Art,
Philadelphia; University of
Colorado Art Gallery, Boulder;
Power Gallery, Toronto; The
Lowe Art Museum, The
University of Miami, Coral
Gables; Santa Monica Museum
of Contemporary Art;
Washington Project for the
Arts, Washington, D.C.

1980
Adrian Piper at Matrix 56,
Wadsworth Atheneum,
Hartford; in conjunction with
Adrian Piper, Real Artways,
Hartford

1971
One Man (sic), One Work, New
York Cultural Center, New
York

1969
Three Untitled Projects (postal),
0 to 9 Press, New York

**SELECTED
GROUP
EXHIBITIONS**

1991
Awards in the Visual Arts,
Hirshhorn Museum and
Sculpture Garden, Washington,
D.C. Will travel to The
Albuquerque Museum of Art,
History, and Science;
Toledo Museum of Art

1990
*Art in Europe and America: The
1960s and 1970s,* Wexner Center
for the Visual Arts, Ohio State
University, Columbus

1989–90
L'Art Conceptuel, Une Perspective,
Musée d'Art Moderne, Paris
(traveling)

1989
*Making Their Mark: Women Move
into the Mainstream 1970–85,*
Cincinnati Art Museum
(traveling)

1988
Committed to Print, The Museum
of Modern Art, New York
(traveling)

*The Turning Point: Art and Politics
in 1968,* Cleveland Center for
Contemporary Arts

Art as a Verb, Maryland Institute
of Art, Baltimore

1985
Kunst mit Eigen-Sinn, Museum
Moderner Kunst, Vienna

*The Art of Memory/The Loss of
History,* The New Museum of
Contemporary Art, New York

1981
The Gender Show, Group Material,
New York

1980
*Issue: Twenty Social Strategies by
Women Artists,* Institute of
Contemporary Arts, London

1977
Paris Biennale, Musée d'Art
Moderne, Paris

1975
Bodyworks, Museum of
Contemporary Art, Chicago

1971
Paris Biennale, Musée d'Art
Moderne, Paris

1970
Information, The Museum of
Modern Art, New York

1969
LANGUAGE III, Dwan Gallery,
New York

Concept Art, Städtisches Museum,
Leverkusen

Plans and Projects as Art,
Kunsthalle, Bern

**SELECTED
BIBLIOGRAPHY**

Berger, Maurice. "The Critique
of Pure Racism. An Interview
with Adrian Piper." *Afterimage*
(October 1990): 5–9.

Borger, Irene. "The Funk
Lessons of Adrian Piper."
Helicon Nine (1986): 150–53.

Brenson, Michael. "Adrian
Piper's Head-On Confrontation
of Racism." *The New York Times,*
26 October 1990, C36.

Farver, Jane. "Adrian Piper."
Adrian Piper: Reflections 1967–87.
Retrospective catalogue (New
York: The Alternative Museum,
1987).

Goldberg, Roselee. "Public
Performance, Private Memory"
[with Laurie Anderson, Julia
Heyward, and Adrian Piper].
Studio International (July–August
1976): 19–23.

Left: VOTE/EMOTE. 1990. Wood shelf with four silk-screened lightboxes, pens, paper, 7' x 13'8½" x 48¾".
Shown installed at John Weber Gallery, New York, 1990. *Photo: Fred Scruton*

Right: Untitled construction. 1967. Wood and paint, 36" x 6'. *Photo: the artist*

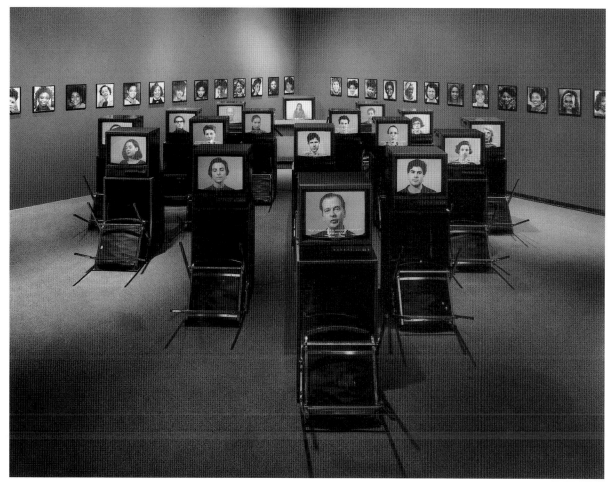

Grigsby, Darcy Grimaldo. "Dilemmas of Visibility: Contemporary Women Artists' Representations of Female Bodies." *Michigan Quarterly Review* (Fall 1990): 584–618.

Hayt-Atkins, Elizabeth. "The Indexical Present: A Conversation with Adrian Piper." *Arts Magazine* (March 1991): 48–51.

Johnson, Ken. "Being and Politics." *Art in America* (September 1990): 154–61.

Kosuth, Joseph. "Art After Philosophy II." *Studio International* (November 1969): 161.

Lewis, JoAnn. "Images That Get Under the Skin." *The Washington Post*, 22 June 1991, G1, G5.

Lippard, Lucy. "Catalysis: An Interview with Adrian Piper." *NYU Drama Review* (March 1972): 76–78.

Marks, Laura U. "Adrian Piper: Reflections 1967–1987." *Fuse* (Fall 1990): 40–42.

Mayor, Rosemary. "Performance and Experience." *Arts* (December 1972): 33–36.

Menaker, Deborah. *ARTWORKS: Adrian Piper.* Exhibition catalogue (Williamstown: Williams College Museum of Art, 1990).

Paoletti, John. "Adrian Piper." *Adrian Piper: Reflections 1967–1987.* (New York: John Weber Gallery, 1989).

Phillpot, Clive. "Adrian Piper: Talking to Us." *Adrian Piper: Reflections 1967–87.* Retrospective catalogue (New York: The Alternative Museum, 1987).

Raven, Arlene. "Civil Disobedience." *The Village Voice*, 25 September 1990, Arts Section cover and 55, 94.

Rinder, Lawrence. Artist's sheet. *Adrian Piper: MATRIX/ BERKELEY*, University Art Museum, Berkeley, mid-August–early November 1989.

Sims, Lowery Stokes. "The Mirror The Other." *Artforum* (March 1990): 111–15.

Thompson, Mildred. "Interview: Adrian Piper." *Art Papers* (March–April 1988): 27–30.

Watkin, Mel. *The Racist Within: Some Personal Observations.* Brochure accompanying the exhibition *What It's Like, What It Is, #1* (Washington, D.C.: Washington Project for the Arts, 1991).

OUT OF THE CORNER. 1990. Video installation with seventeen monitors, sixty-four black and white photographs, one overturned table, sixteen overturned chairs, and music soundtrack. Shown installed at the Whitney Museum of American Art, New York, 1990. *Photo: David Allison*

Published on the occasion of the exhibition *Dislocations*
Organized by Robert Storr, Curator,
Department of Painting and Sculpture,
The Museum of Modern Art, New York
October 20, 1991–January 7, 1992

The exhibition and catalogue are made possible by generous grants from the Lannan Foundation, the Peter Norton Family Foundation, the National Endowment for the Arts, Agnes Gund and Daniel Shapiro, Marcia Riklis Hirschfeld, Mayer and Robert Mnuchin, The Andy Warhol Foundation for the Visual Arts, Inc., The Contemporary Arts Council of The Museum of Modern Art, The Folio Foundation and The Junior Associates of The Museum of Modern Art.

Library of Congress Catalog Card Number: 91-61338
ISBN 0-87070-182-7 (MoMA)
ISBN 0-8109-6100-8 (Abrams)

Printed in the United States of America

Produced by the Department of Publications,
The Museum of Modern Art, New York
Osa Brown, Director of Publications
Edited by Alexandra Bonfante-Warren
Designed by Dreenie Doyle Barnes
Production by Marc Sapir
Printed by Fleetwood Litho & Letter Corp., New York, NY
Bound by Bernard Schober Intergraphic Binding & Finishing Co., Montclair, NJ

Published by The Museum of Modern Art
11 West 53 Street, New York, New York 10019
Distributed in the United States and Canada by Harry N. Abrams Inc., New York,
A Times Mirror Company
Distributed outside the United States and Canada by Thames and Hudson, London

Cover photo:
© Scott Frances/Esto

Soundtrack of *What It Is Like, What It Is, #3*: The Commodores, "Zoom," © 1977 Motown Records

The Kabakov's installation *The Bridge* includes the following paintings by the artist: *Bathhouse,* 1970. Enamel on plywood, 67¼" x 78¼". Collection Dina Vierny, Paris. *Fine Art,* 1981. Enamel on masonite, 71¼" x 50¾". Courtesy Dina Vierny, Paris, and Ronald Feldman Fine Arts, New York. *Art Show,* 1982. Enamel on masonite, 80" x 67¼". Private collection, Bern. *Government 208.* Enamel on masonite, 55½" x 62½". Courtesy Dina Vierny, Paris, and Ronald Feldman Fine Arts, New York. *In the Closet,* 1969. Enamel on masonite, 49¼" x 63½". Collection Dina Vierny, Paris. *Two Preliminary Cases for Universal,* 1969. Enamel on masonite, 49¼" x 63¾". Collection Dina Vierny, Paris. *Box at the Bottom,* 1969. Enamel on masonite, 49¼" x 63½". Collection Dina Vierny, Paris. *New 368.* Enamel on masonite, 49¼" x 59". Courtesy Dina Vierny, Paris, and Ronald Feldman Fine Arts, New York. *On the Blue,* 1974. Enamel on masonite, [...] x 63½". Private collection, Bern. *On the Floor 82.* 55¼" x [...]. Enamel on masonite, [...] x 63½". Private collection, Bern. *Dovzhenko Plant,* 1969. Enamel on masonite, 57¼" x 63". Courtesy Dina Vierny, Paris, and Ronald Feldman Fine Arts, New York. *The Holiday,* 1970. Enamel on masonite, 49½" x 63¾". Collection Dina Vierny, Paris. *Perhaps We Had to Get Lost in This Weather,* 1982. Enamel on masonite, 49¼" x 68". Courtesy Ronald Feldman Fine Arts, New York.

ACKNOWLEDGEMENTS I am new to the museum world. That fact has made me especially aware of the debt I owe to the many seasoned people who have devoted their skills, imagination, and good will to this exhibition. There is not enough space to name them all, nor are the names I cite below in any order of importance. Nevertheless, I would like to thank Richard Oldenburg; Agnes Gund; Cora Rosevear; Fereshteh Daftari; Jody Hanson; Tavia Fortt; Marc Sapir; Alexandra Bonfante-Warren; Karen Meyerhoff; Aileen Chuk; Barbara London; Jerome Neuner; Philip Yenawine; James Snyder; Dan Vecchitto; Richard Palmer; Eleni Cocordas; Don McLeod; Emily Kies-Folpe; Joan Howard; Noriko Fuku; my unflappable assistant, Alina Pellicer; Dawoud Bey; Scott Frances; Peter Moore; and all the staff members who participated in Sophie Calle's project. I would also like to thank my colleagues Carolyn Lanchner, Kynaston McShine, and Laura Rosenstock for welcoming a newcomer to the Museum. My special thanks go to Kirk Varnedoe for inviting me at all. | The exhibition and catalogue were made possible by generous grants from the Lannan Foundation, the Peter Norton Family Foundation, the National Endowment for the Arts, Agnes Gund and Daniel Shapiro, Marcia Riklis Hirschfeld, Meryl and Robert Meltzer, The Andy Warhol Foundation for the Visual Arts, Inc., The Contemporary Arts Council of The Museum of Modern Art, The Bohen Foundation, and The Junior Associates of The Museum of Modern Art. | For their support in producing this catalogue, I would like to thank the Department of Publications, Osa Brown, Director; Harriet S. Bee, Managing Editor; Nancy Kranz, Manager of Promotion and Special Services; Timothy McDonough, Production Manager; and the Graphics Department and its Director, Michael Hentges. For their participation in installing *Dislocations* in The Museum of Modern Art, I would particularly like to acknowledge the following staff members: Workshops: Foreman Carpenter, Attilio Perrino, Francis O'Donohue, Giuseppe Maraia, Frank Peables, George Sivulka, Chris Van Alstyne, Gunther Wildgrube; Exhibition Production: Douglas Feick, Robert Stalbow; Film Department: Charles Kalinowski, Anthony Tavolacci; Frame Shop: Laura Foos; Housekeeping: Housekeeping Manager, Naomi Del Bianco, Dominick Tomasello; Building Operations: Supervisor, Peter Geraci, Zinovy Galinsky, Ron Genovese, Ilie Marinescu, Robert Pizzurro; Painters' Shop: Supervisor, Desire Van Hove, Santos Garcia, Don Peters; Preparators: Supervisor, Gilbert Robinson, Christopher Engel, Stanley Gregory, Joe Matellio, David Moreno; Security: Elroy Clarke. | The following outside people participated in the installations: *The Other Vietnam Memorial:* Chris Bakala, Tim Brennan, Chris Buck, David Carlson, Mike Czuba, Paul Dickerson, Sue Evans, Peggy Reynolds of Immaculate Construction, Leo Modrcin, Peter Engel and Wes Pittenger of New Cut, Inc., Chester Poplaski, Mick Raffle, Jim Schmidt, Larry King and William Nitzberg of Technology for the Arts, Rirkit Tiravanija, and Sven Travis; *Ghosts:* Takeshi Arita, Paulette Giguere, David Ravitch; *Public Enemy:* Jules Allen, A. C. Hudgins, George Mingo; *The Bridge:* Emelia Kanevsky, Chuck Agro; *Anthro/Socio:* Dennis Diamond, Rinde Eckert, Juliet Myers, Video D Studios, Inc.; *What It's Like, What It Is, #3:* John L. Moore III, Paul Coffrey of George Washington University T.V., Susanna Singer, Karl Kalbaugh of Soundwave, Inc., Steve Dougall of Technovision, and Matt Dibble of Videosphere.

TABLE OF CONTENTS

INSTALLATIONS